CW00546777

Contents

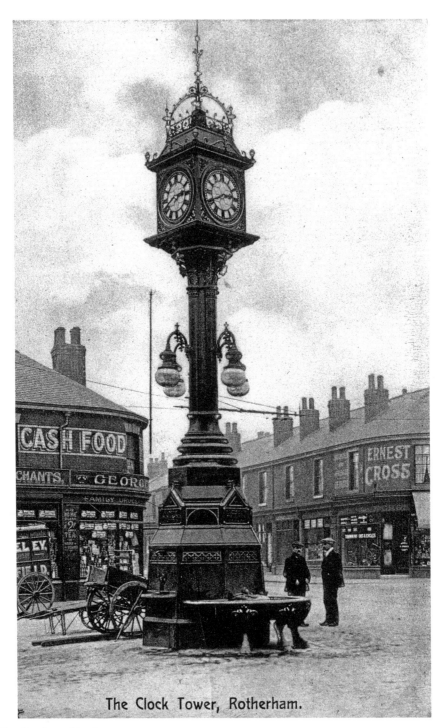

The Clock Tower, Rotherham.

The Hastings Clock

This clock was gifted to the town by James Hastings, a local businessman. It was unveiled in Effingham Square on 20 June 1912 to commemorate the coronation of Edward VII. It was moved to the junction of Effingham Street, Frederick Street and Drummond Street in 1963 but has now been returned to its original site in Effingham Square. It was given Grade II-listed status in 1986.

IN & AROUND ROTHERHAM

From Old Photographs

MELVYN JONES AND MICHAEL BENTLEY

AMBERLEY

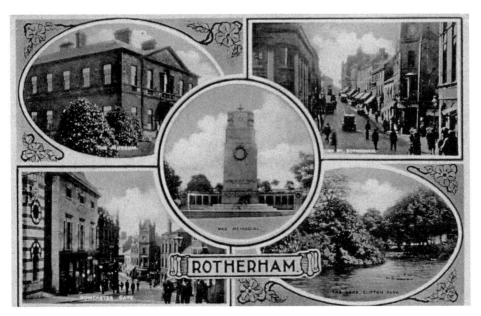

Views of Rotherham
Clockwise from left to right: Clifton House, High Street, Clifton Park, Doncaster Gate; centre: the war memorial in Clifton Park.

First published 2018

Amberley Publishing
The Hill, Stroud
Gloucestershire, GL5 4EP

www.amberley-books.com

British Library Cataloguing in Publication Data.
A catalogue record for this book is available from the British Library.

ISBN 978 1 4456 7590 9 (print)
ISBN 978 1 4456 7591 6 (ebook)

Origination by Amberley Publishing.
Printed in the UK.

Introduction

Rotherham has been an important market town for a wide surrounding area since at least the thirteenth century. This hinterland contained scores of villages and hamlets by the end of the medieval period. Many of these became industrialised and grew rapidly – like the town itself – as coal mining, iron and steel making, glass making and pottery manufacture grew and spread in the second half of the eighteenth century and in the nineteenth century. Today this area is Rotherham Metropolitan Borough, which stretches from Harley in the west to Firbeck (17 miles to the east), and from Wath in the north to Harthill (15 miles to the south).

The area has undergone profound change in the last century or so. There has been much demolition and rebuilding in the town centre. The town has grown outwards in all directions and the surrounding settlements, rural and industrial, have been transformed in many cases. Many working patterns and workplaces have disappeared, means of transport have changed out of all recognition and even how people used their leisure time in the early twentieth century shows some striking differences from today.

Fortunately, in the latter years of the nineteenth century and during the first half of the twentieth century the town and its surrounding settlements were recorded on camera for posterity. This was done for a variety of reasons. Businesses wanted to record their activities, families wanted to record family events and the family photographic album came into existence, local newspapers used photographs to record civic and other events taking place in their readership areas and of course, most importantly, the picture postcard came into existence.

The postcard as we know it today came into existence in January 1902. From that date, what was to become until recent times the standard-sized card – 5½ inches by 3½ inches – was allowed by the Post Office to have one side entirely devoted to an illustration in the form of a photograph, painting or engraving, and the other side divided into two with room for a message on the left and the address on the right. With as many as five deliveries a day from Monday to Saturday and one on Sunday morning, postage costing only a halfpenny, and cards posted locally often being delivered on the same day as they were posted, picture postcards became the standard way of communicating between places in the days before most people had a telephone. As a result, photographic firms rushed to fill the booming market for postcards featuring photographs of local places and people. Everybody sent and received them. The Post Office dealt with 866 million postcards through the post in the year 1909 alone.

The early postcards, studio photographs, family photographs and commercial photographs tell us so much about our local history: about how the landscape has changed; about

changing fashions; and about local industry, to name but three obvious areas of interest. But there is so much more. No street, group, event, or subject was too small to be recorded on camera.

This collection of 240 old photographs, mostly from private collections and many of them not published in a local book before, provides a comprehensive pictorial history of the area. The images and the related captions will take long-established residents on an affectionate tour of their past, and for relative newcomers they may be something of a revelation.

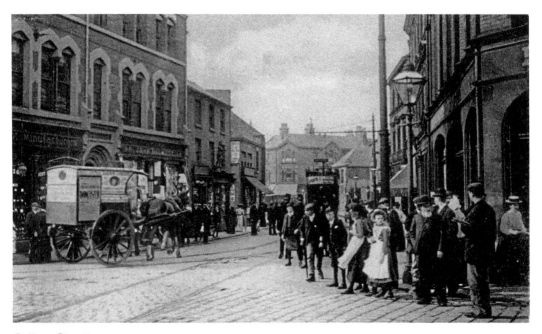

College Street
This busy commercial street in the middle of the town is shown on a postcard produced more than 100 years ago. A horse-drawn commercial vehicle trundles down the cobbled street towards the oncoming tram, no doubt full of shoppers.

The Old Town

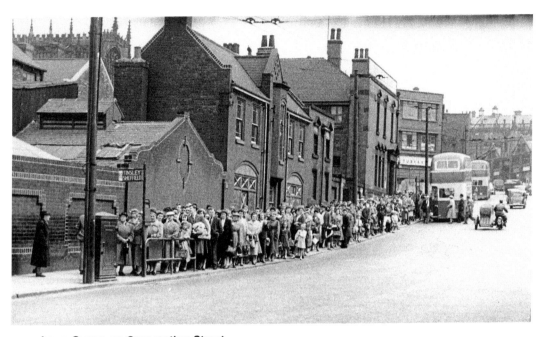

Long Queue on Corporation Street

The oldest streets in the town are in fact called 'gates' not streets: Bridgegate, Doncaster Gate, Hollowgate, Moorgate, Wellgate and Westgate. But they are not gates at all; the name is descended from the Old Norse word *gata*, which means 'street' or 'lane'.

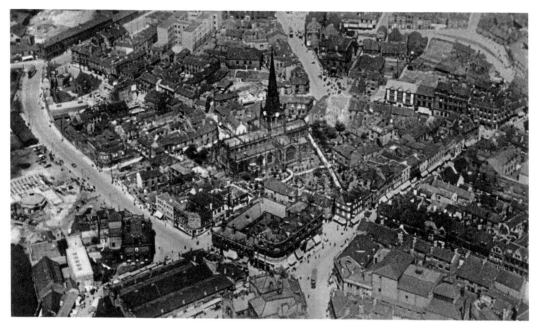

Aerial View of Central Rotherham

All Saints' Church, now the minster, dominates the scene. In the right foreground High Street runs away towards College Street and Wellgate. Beyond the parish church is the wide Effingham Street.

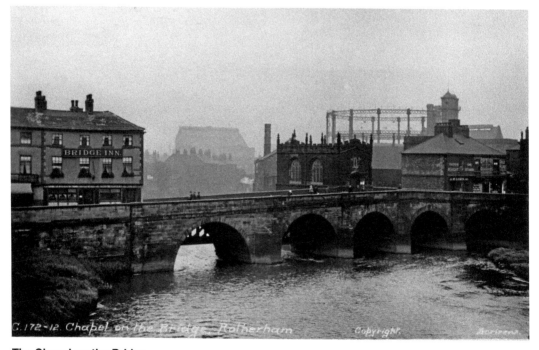

The Chapel on the Bridge

Rotherham's medieval chapel on the bridge across the River Don is one of only four such chapels in the country. The others are at Wakefield in West Yorkshire, St Ives in Huntingdonshire and Bradford-on-Avon in Wiltshire.

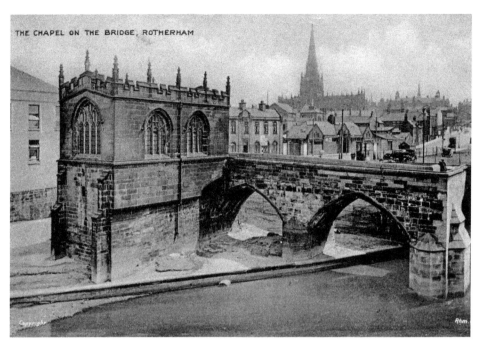

Another View of the Chapel on the Bridge
At the chapel medieval travellers would give thanks for their safe arrival in the town or pray for a safe journey when leaving it.

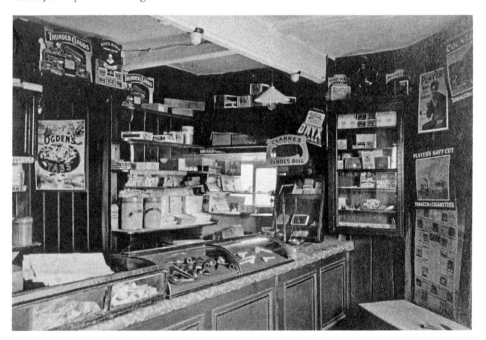

Interior View of the Chapel
After the Reformation the chapel was converted into almshouses, then used as the town jail, then a private residence. By the beginning of the twentieth century, as shown here, it was a tobacconist's shop. It was reconsecrated by the Bishop of Sheffield in 1928.

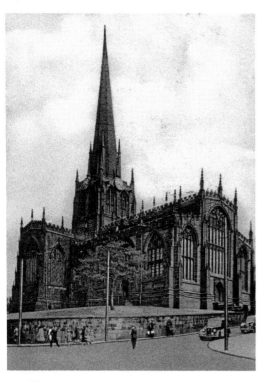

All Saints' Church, Rotherham
The church was granted minster status in
2004. It began as a small Saxon church,
developed into a larger Norman church and
was then rebuilt in the Perpendicular style
in the late Middle Ages. It is regarded as
one of the most magnificent parish churches
in Yorkshire.

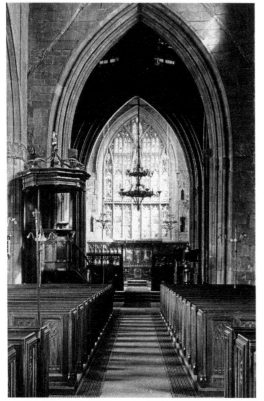

Interior of the Minster
The interior of Rotherham Minster is full of
interesting features. Separating the nave from
the aisles are piers decorated with carvings
of Green Men. There are beautifully panelled
roofs to the nave and chancel, a fine brass
commemorating the Swift family, and a plaque
to the fifty men and boys who perished in a
boating disaster during a launch into the canal
at Masbrough on 5 June 1841.

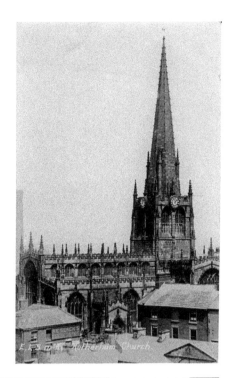

A View Towards the Minster over the Shambles

The Shambles contained butchers' stalls. The building at the left-hand end of the row of buildings beyond the Shambles is the Old Ring O' Bells public house.

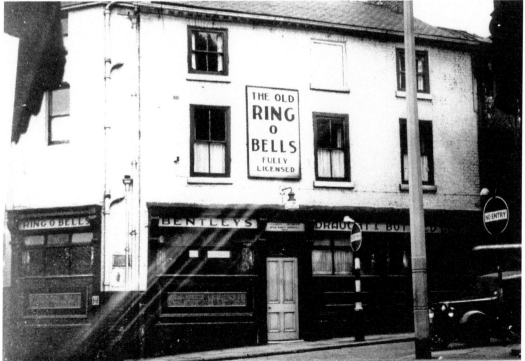

The Old Ring O' Bells

Older patrons of the now demolished public house still remember the urinals that were outside: a tight squeeze and constructed entirely of metal, they were usually referred to as the iron lung!

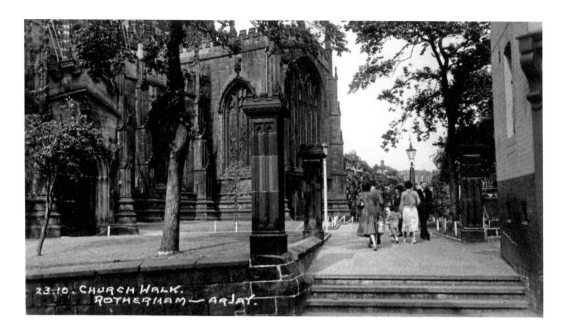

Church Walk

The tree-lined Church Walk runs beside the minster between Church Street and College Street and is a quiet backwater in the town centre.

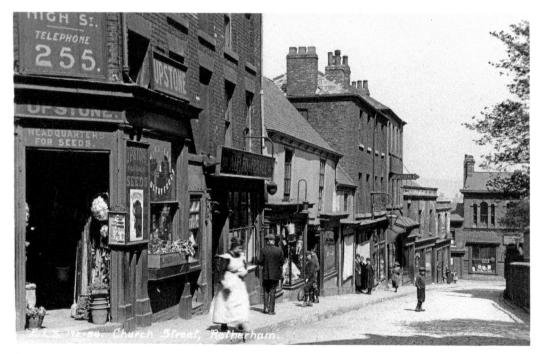

Church Street

Church Street is shown as it was before all the buildings were demolished, rebuilt and demolished again to make way for the Minster Gardens. The shop on the extreme left announces over the doorway that it is the 'HEADQUARTERS FOR SEEDS'.

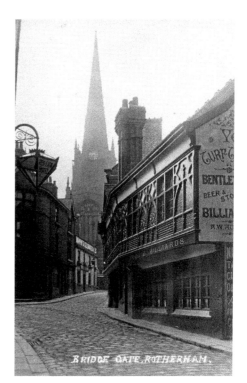

Bridgegate Looking Towards the Minster

The name Bridgegate simply means the street leading to and from the bridge over the River Don at the western entrance to the town. The street shown in this photograph is quite unlike the modern, wide, pedestrianised street today.

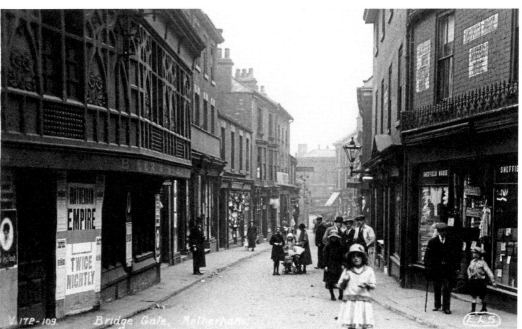

Another View of Old Bridgegate

This time we are looking the other way. The elaborately timbered building in both photographs is the Old Turf Tavern, which was demolished as part of the road-widening scheme.

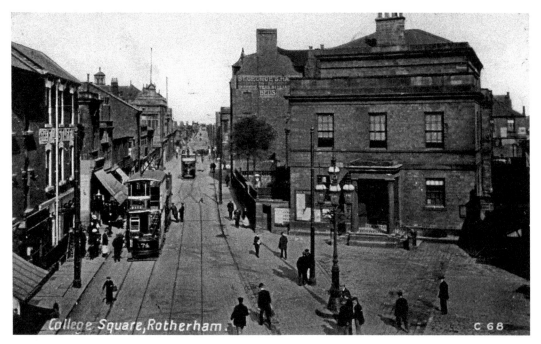

College Square, Looking down Effingham Street
This was an important tramway route. In the right foreground is the courthouse.

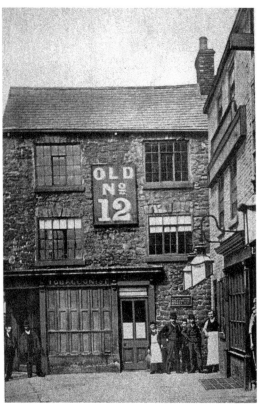

The Old No. 12
The Old No. 12 was once a prominent landmark projecting out at the bottom of College Lane into College Street. The name and the large name board led first-time visitors to the town to believe it was a public house. In fact, it was a grocery store and then a tobacconist's.

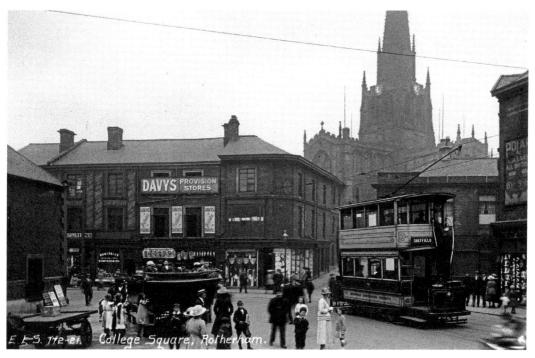

College Square Looking Towards the Minster

Three modes of transport are shown in this view of College Square looking towards the minster. In the left foreground is a horse-drawn cart, in the centre is a charabanc, and on their right a tram indicating it is about to set off on the 6-mile journey to Sheffield.

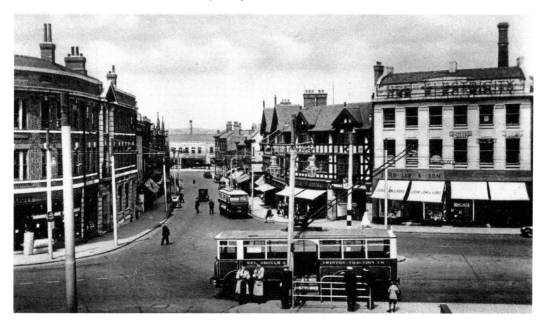

College Square Looking Towards Bridgegate

College Square, now renamed All Saints Square, is shown looking towards the widened Bridgegate, which was still used by vehicles when this photograph was taken. It is now pedestrianised.

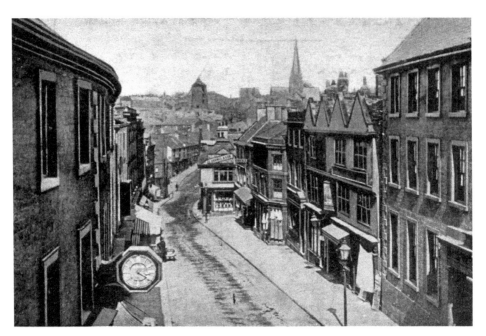

Looking down High Street

Mason's (the jeweller's) clock is in the left foreground. The clock was originally on the *Daily Express* offices in Fleet Street, London. On the right are the gables of the fifteenth-century Three Cranes Inn and in the background is one of the two windmills that stood on Doncaster Gate.

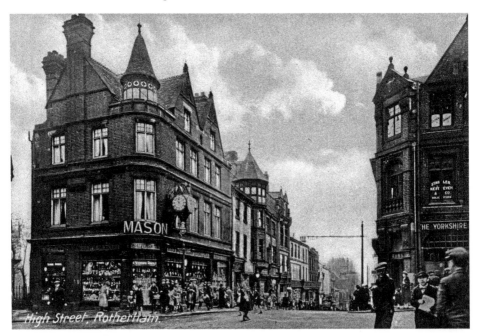

The Top of High Street

Mason's, the jeweller's, occupies the prominent position at the top of the street. John Mason had a jeweller's shop in the town as early as the 1850s. The shop shown here was occupied from 1883, when it was extensively rebuilt.

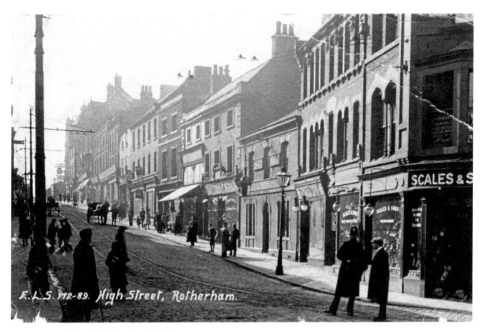

The Right-Hand Side of High Street

This view is up the right-hand side of High Street with Scales & Sons' boot and shoe emporium on the corner, which was later occupied by Montague Burton's men's outfitter store. The clock on Mason's, the jeweller's at the top of the street, can just be seen.

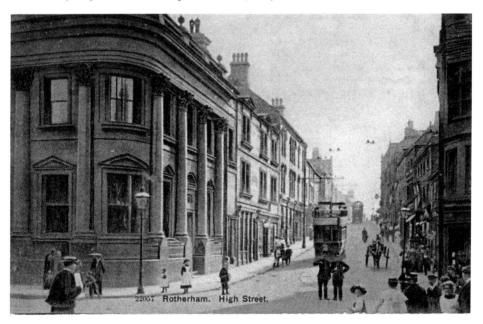

The Left-Hand Side of High Street

This is another view up High Street with the left-hand side in full view, showing the imposing architecture of what was originally the site of the Sheffield and Rotherham Bank (which then became Williams Deacon's Bank and is now the Royal Bank of Scotland) on the corner with Wellgate. The building shown was built in 1892 to replace an earlier bank.

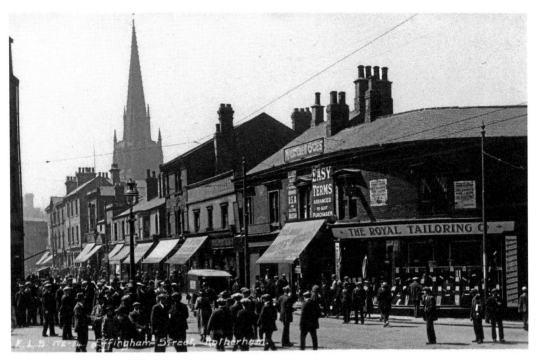

Effingham Street

The street is crowded with flat-capped gentlemen. Are they contemplating using the services of the Royal Tailoring Co. or wondering whether to buy a BSA or a Raleigh bicycle from the bike shop next door?

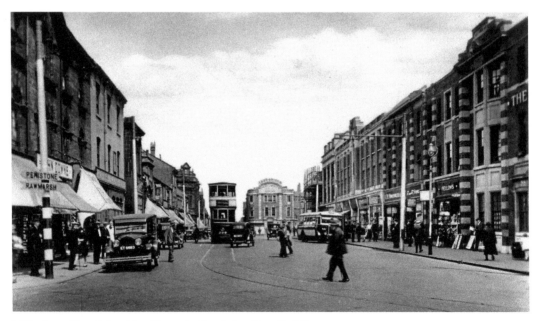

Effingham Street, Looking Towards the *Advertiser* Building

The *Advertiser* building started life as a Zion chapel before being converted into a cinema (at first called the Electra Picture Palace and then the Pavilion). The cinema was closed in 1930.

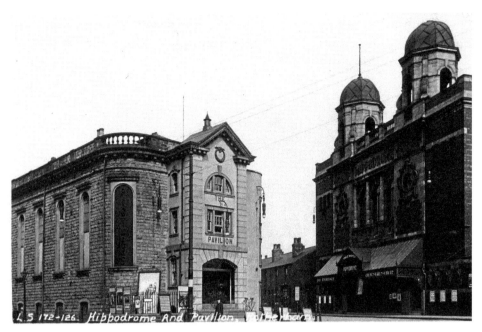

A View of the Old Pavilion Cinema

This picture was taken before it had been converted for use by the printers and publishers of the *Rotherham Advertiser*. Boots the chemist have occupied the site since 1987. On the right is the Hippodrome theatre, which opened in 1908. In 1932 it closed for a short period and then reopened as a cinema. It finally closed in December 1959.

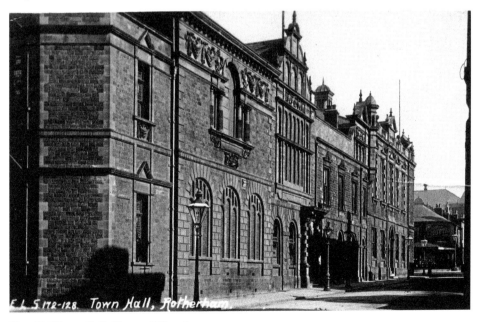

The Old Town Hall, Howard Street

The building was originally the site of the offices of the Rotherham and Kimberworth Board of Health. They were taken over by the newly created Rotherham Borough Council in 1871. The buildings were remodelled in 1895.

College Street

The street is crowded with pedestrians on a busy Saturday.

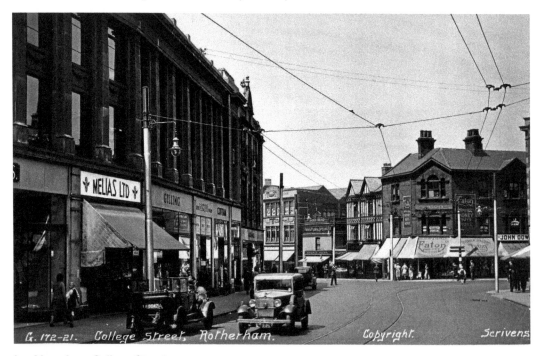

Looking along College Street

Effingham Street is in the background to the right. Besides Melias, the familiar high street grocery store, are Gilling's drapery store and (in the background on Effingham Street) Eaton Ltd, hosiery and gloves outfitters, 'Where Money Buys More' as they proudly announce on the awning above the shop window.

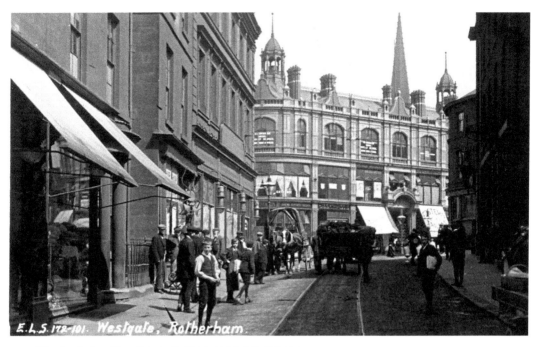

Westgate Looking Towards the Imperial Buildings

The view is north-west, near the top of Westgate and towards the imposing Imperial Buildings that replaced the Shambles in 1907 to a design by Joseph Platts. Beyond the Imperial Buildings is the spire of the parish church, which that dominates the town from all angles.

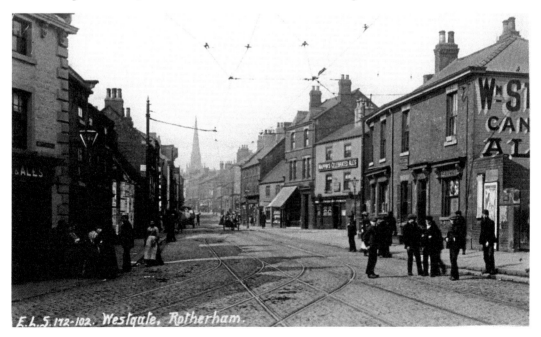

The Parish Church from Westgate

A more distant view of the parish church spire can be seen from Westgate. Along the street various drinking establishments are boldly advertising the ales on sale.

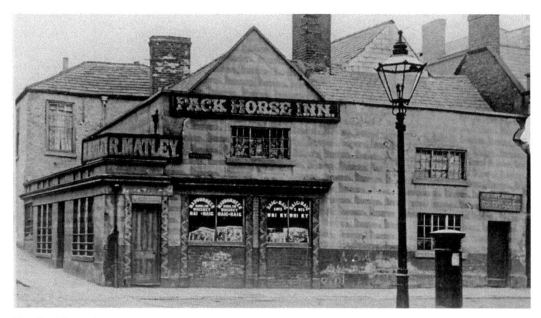

The Packhorse Inn

This inn stood on the corner of Doncaster Gate and Wellgate. As its name suggests, this was on a packhorse route through the town from the west and eastwards towards Doncaster and Tickhill. Significantly, when it was put up for sale in 1902 it was said that at the rear of the inn there was stabling for twelve horses.

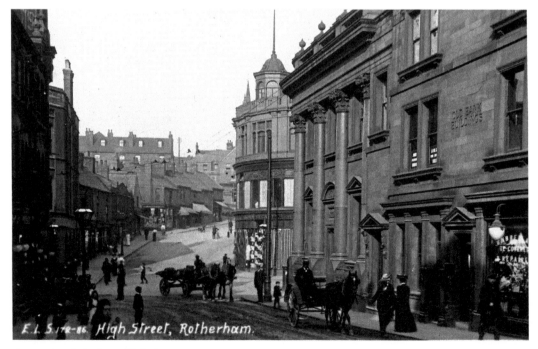

Doncaster Gate from High Street

A view up Doncaster Gate from High Street more than 100 years ago. At the bottom of High Street on the right are the 'Old Bank Buildings'.

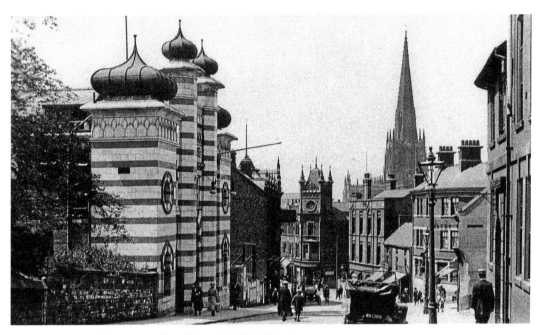

View down Doncaster Gate Towards High Street

The view is dominated by the Cinema House, which opened in 1914, with its Moorish-style architecture. In the week commencing 19 March 1928, you could go there and see the silent film *What Price Glory?* said to be, according to the *Rotherham Advertiser*, 'the world's greatest motion picture' starring Dolores del Rio.

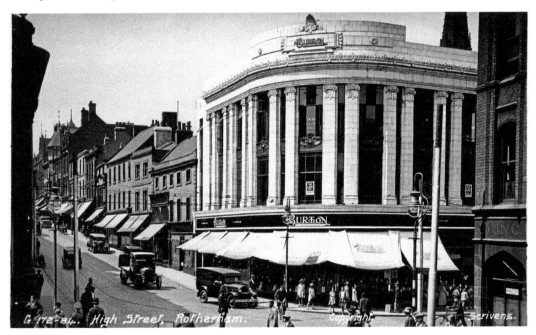

High Street from Doncaster Gate

A view from Doncaster Gate onto High Street, showing Montague Burton's men's outfitters store at the bottom of High Street, which was built in 1931.

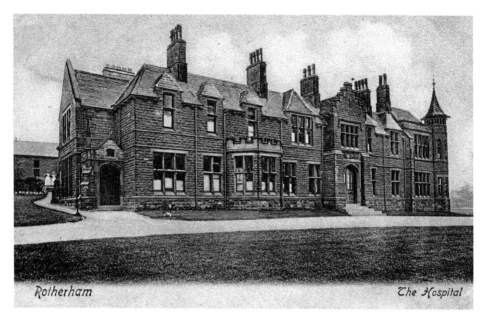

Rotherham The Hospital

Doncaster Gate Hospital

The hospital, which originally stood in extensive grounds, was built where Doncaster Gate became Doncaster Road. The first stone was laid in January 1870. It was completed the following year at a cost of £10,000. Subsequently, a mortuary and disinfecting ward were added and a children's ward was built in 1897.

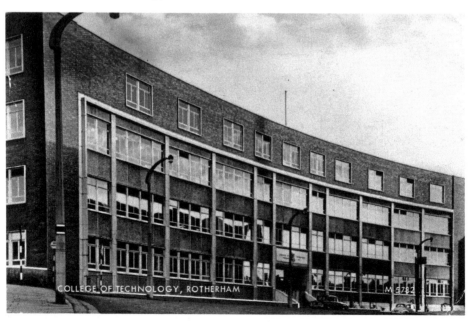

COLLEGE OF TECHNOLOGY, ROTHERHAM M 5782

The Clifton Building of the Rotherham College of Arts and Technology

This building on Howard Street dates from 1960. Since that time the college has expanded greatly, including expansion on Eastwood Lane, the incorporation of the Rother Valley College at Dinnington and a merger with the North Notts College at Worksop. Every year it educates 2,000 sixteen to eighteen year olds and 5,000 adult learners on short courses.

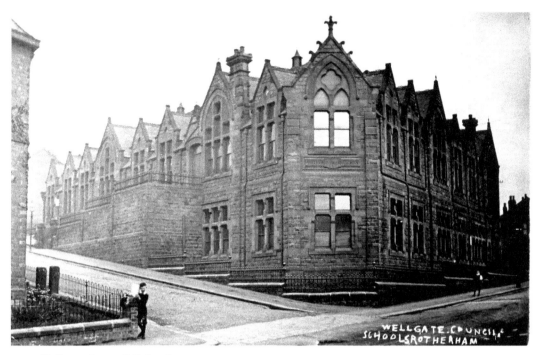

Wellgate Council School

The school stood at the far end of Wellgate at its junction with Aldred Street. The school was erected in 1879, enlarged in 1885 and further enlarged in 1898. By 1902 more than 800 children were in attendance. It has now been demolished.

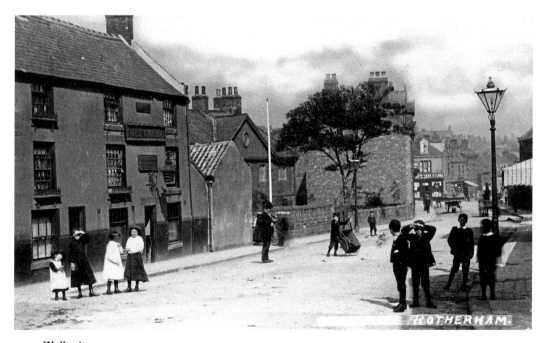

Wellgate

This view shows Wellgate in the 1920s with the Three Tuns Inn on the left. Wellgate Old Hall can be seen standing back from the road.

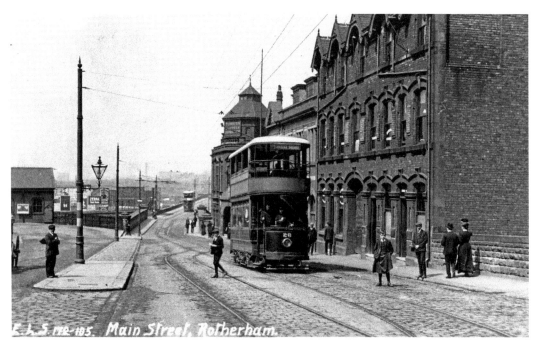

Main Street

The tram stands outside Rotherham's main post office, which was erected in 1870. Beyond the post office are the public baths and library, which opened in 1887.

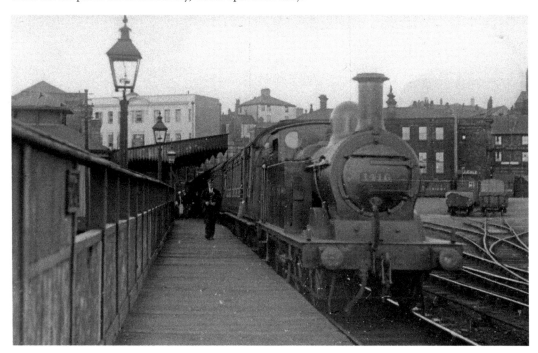

Westgate Railway Station

The station stood at the junction of Westgate and Main Street. It was the terminus of the Sheffield and Rotherham Railway, opened to traffic in 1838. The station closed in 1952.

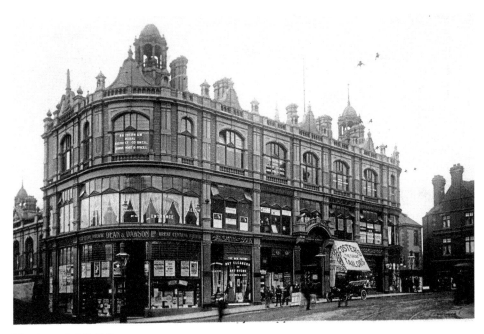

The Imperial Buildings

The Imperial Buildings replaced the Shambles in 1907. There were shops on the outside and inside (around a courtyard with a glazed roof). Above the shops were offices, which have now been converted into apartments.

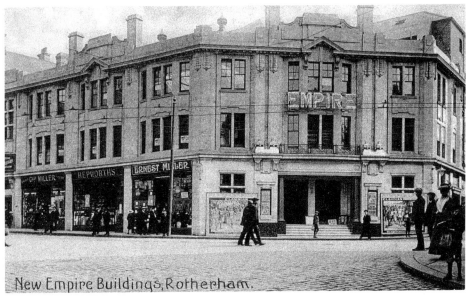

New Empire Buildings, Rotherham.

The Empire Buildings

Located at the junction of High Street and Ship Hill, the Empire Buildings incorporated the Empire Theatre, which was opened in 1913 and converted into a cinema in 1921. After three changes of name it closed in 1990, when it was the last cinema in the centre of Rotherham. The part of the building that held the cinema is now occupied by Amber Lounge, a cocktail lounge and bar.

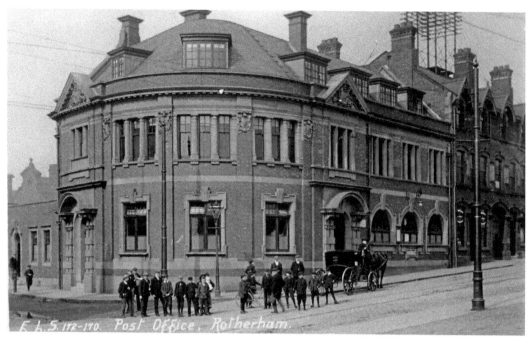

Another View of the Post Office in Main Street

This shows another view of the post office in Main Street with a horse-drawn carriage and a gang of onlookers, mostly boys, who no doubt had been trailing the photographer round the town.

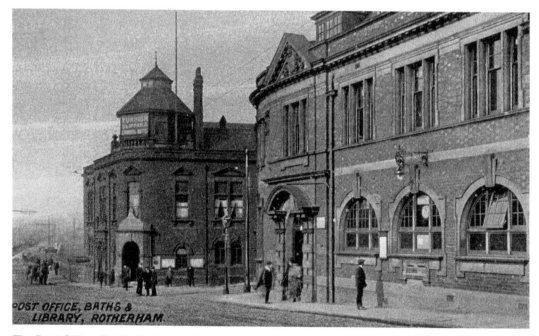

The Post Office, Public Baths and Library, Main Street

The post office, as already mentioned, was opened in 1870. The public baths and public library that stand on the corner of Main Street and Market Street were opened in 1887 as part of Rotherham's celebrations for Queen Victoria's Jubilee.

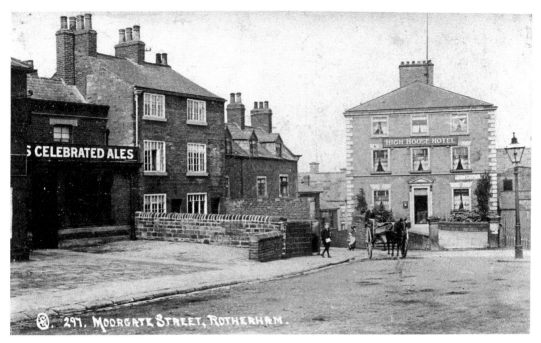

Moorgate Street

This street was constructed in the 1880s to connect Moorgate with High Street. It runs past the right-hand side of the High House Hotel. The hotel was in existence as early as 1856 and must have been overflowing on market days.

A View at the Bottom End of Moorgate Street

We are looking towards High Street with All Saints' Church (now the minster) beyond.

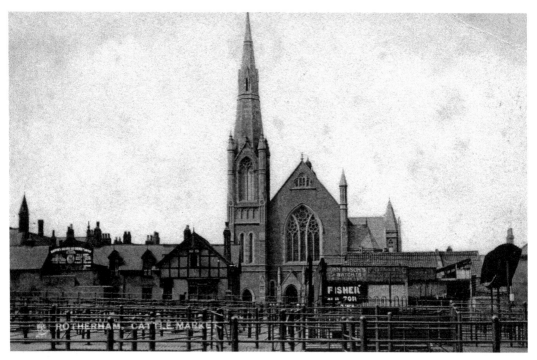

The Old Cattle Market

This is the area between the new Town Hall and Talbot Lane chapel on Moorgate Street, now mostly used for car parking. In its day the market attracted butchers from across the Pennines from Manchester and Stockport.

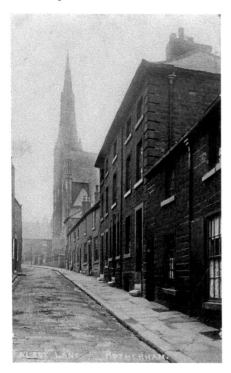

Talbot Lane

Talbot Lane ran roughly parallel to Moorgate Street in front of Talbot Lane chapel. The present chapel is the third one on the site and was built in 1903. It has seating for 850 people.

The Expanding Town

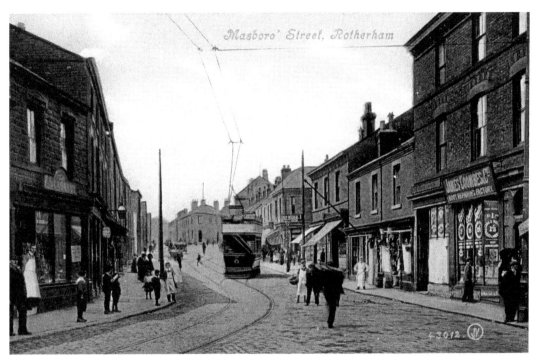

Masbrough Street, Masbrough

From the second half of the eighteenth century the town grew outwards in all directions as it played a leading role in the Industrial Revolution. This included not only industrial but also suburban expansion and the provision of public open space. Shown here is Masbrough Street, an important street in the industrial satellite of Masbrough, just across the River Don from the old town. Masbrough soon became an extension of the old town to the west of the river.

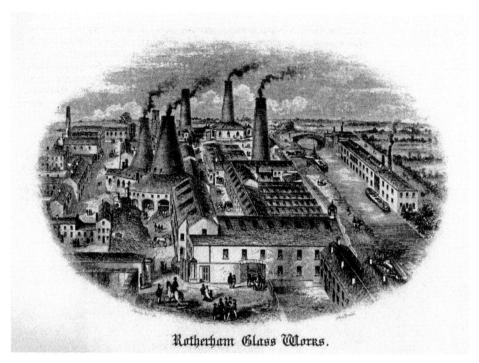

Rotherham Glass Works.

Beatson Clark's Glassworks from an Old Engraving

In a prime position beside the canal and later the railway, a glassworks has operated from the site since 1751. The first member of the Beatson family associated with the works was John Beatson, who leased the works in 1783 in order to set up his son William and nephew Robert in business. John Graves Clark, who married William Beatson's daughter, became a partner in 1828.

Peter Stubs' Warrington Steelworks

The works were located on the site of Holmes Hall, which the firm purchased and demolished in 1842. The six cone-shaped structures are cementation furnaces for making blister steel. They were demolished in 1968 and the plant closed down.

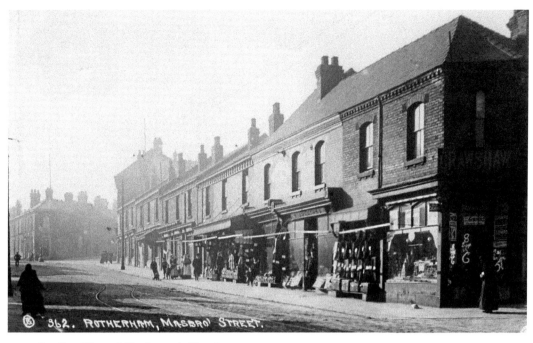

Another View of Masbrough Street

The scene is dominated by William Middleton's clothier's shop, fully stocked with the goods for sale all in well-labelled displays.

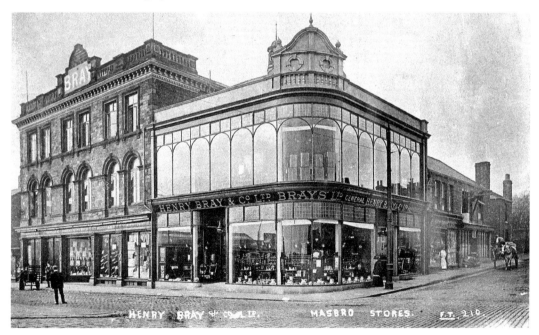

Henry Bray's Store, Masbrough

This view shows the very inviting exterior of Henry Bray's grocery and drapery store in Masbrough. In 1913 the building was converted into the Tivoli cinema. Part of the ground floor on the right-hand side became the Tivoli sweet shop.

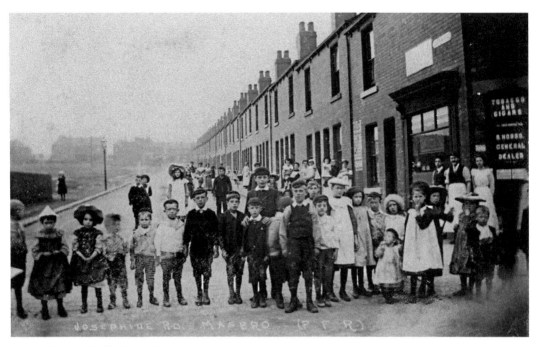

Josephine Road, Masbrough

A row of children in a variety of Edwardian attire line up, while, behind them, mothers hold up babies for the camera. At the corner shop the staff of R. Moses' general dealers and tobacconist's store also pose for the photographer.

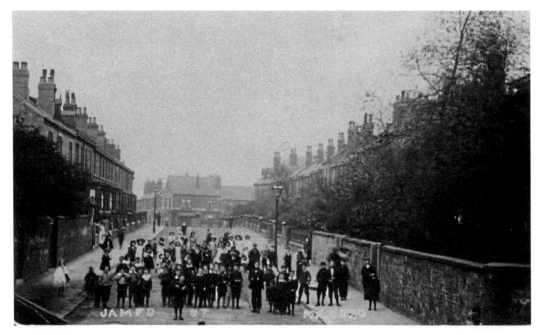

James Street, Masbrough

Another packed street in Masbrough, this time the residential James Street, which is now bisected by New Wortley Road.

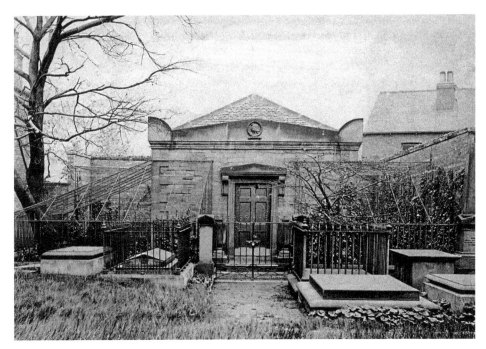

The Walker Mausoleum

The mausoleum was originally called the 'burying house', built between Masbrough Hall gardens and the Masbrough Independent Chapel, for the bodies of members of the Walker family, the Nonconformist industrialists. The mausoleum was built in 1776. The Friends of Walker Mausoleum are currently working to protect the neglected mausoleum.

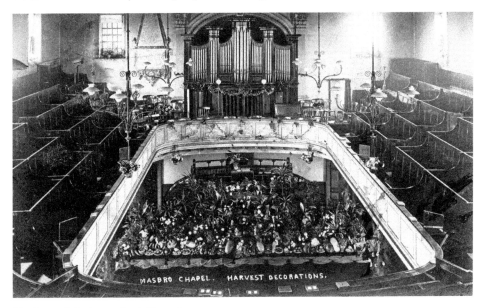

Masbrough Independent Chapel

This interior shot of the now demolished Masbrough Independent Chapel shows the box pews in the upper galleries, the massive organ behind the pulpit and the harvest decorations – fruit, vegetables and flowering plants. The chapel could seat over a thousand worshippers.

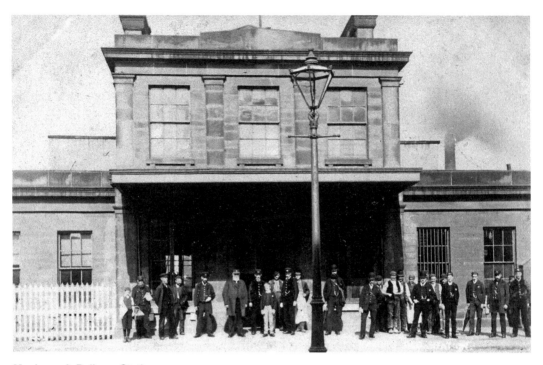

Masbrough Railway Station

The photograph shows station staff outside Masbrough's old railway station, many of them flaunting a watch and chain. Timekeeping was important!

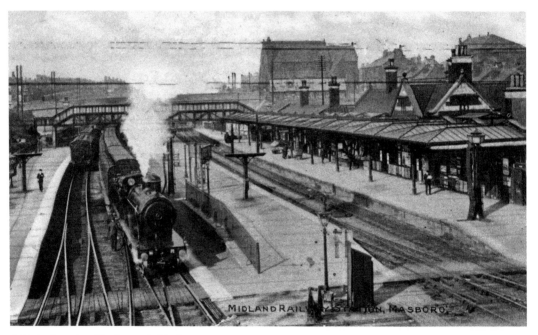

A Train Leaving Masbrough Station

A train leaves Masbrough station on the Midland Railway route between Derby and Leeds. The station was opened in 1840 and closed in 1987 when it was superseded by the new Rotherham Central station.

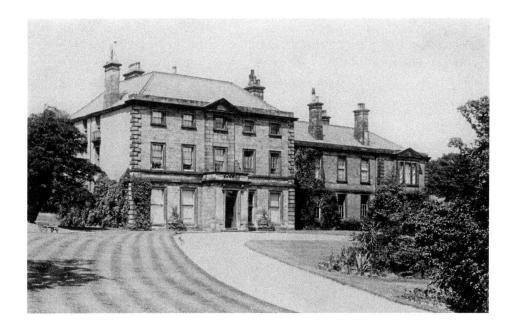

Clough House, Masbrough

Clough House was built in the 1770s by local architect/builder John Platts. It was the home of local businessman George Wilton Chambers for a large part of the nineteenth century. In a nineteenth-century sales advertisement it was described as a 'fine ancestral mansion beautifully situated in tastefully arranged pleasure grounds'. It has now been demolished.

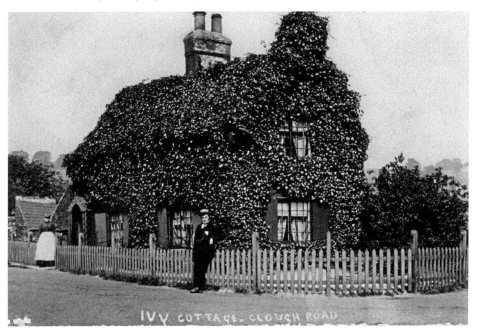

Ivy Cottage, Clough Road, Masbrough

This aptly named cottage looks as if it is set in the deep countryside, not just a few minutes from a noisy and smoky industrial town with a population of more than 60,000 in 1911.

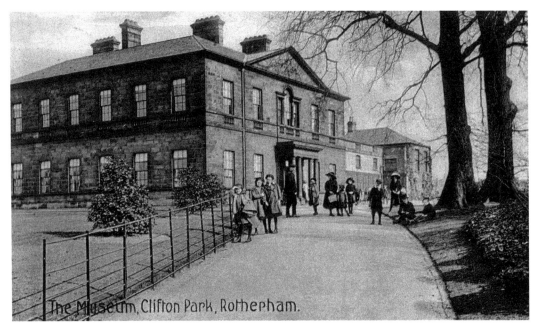

Clifton House

Now Clifton Park Museum and the Local Studies Library and Archives, the house was built in the 1780s for the industrialist Joshua Walker. It is believed to have been designed by the famous architect John Carr of York. The house and its grounds were eventually purchased by Rotherham Corporation in 1891, and the house opened as a museum in 1893.

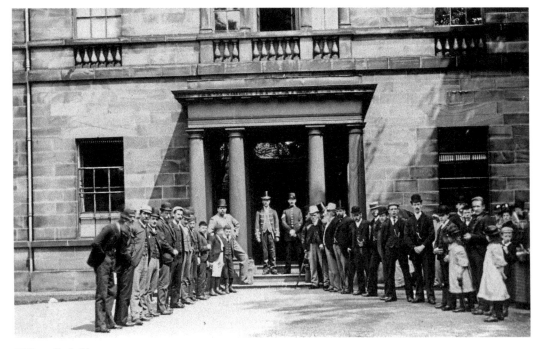

Clifton Park Museum

Clifton Park staff, family and friends outside Clifton House after it became Clifton Park Museum.

The Entrance to Clifton Park

This is the entrance on the corner of Clifton Lane and Doncaster Road in around 1900. The massive stone pillars and cast-iron gates made an imposing entrance to the park. The original gates were removed during the Second World War and later replaced.

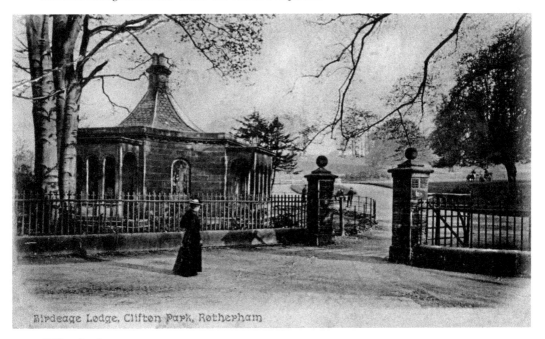

Birdcage Lodge, Clifton Park, Rotherham

Clifton Lodge

Clifton lodge, as it was officially known, marked the entrance to Clifton Park on Doncaster Road. It was known locally as Birdcage Lodge. It was occupied by park keepers until its demolition in 1946.

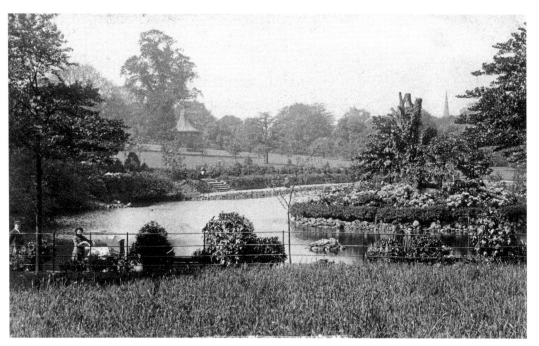

Clifton Park

Clifton Park was officially opened by Prince Edward and Princess Alexandra (later Edward VII and Queen Alexandra) in June 1891. The fishpond near the Birdcage Lodge entrance was enlarged into a shallow lake with fountains and waterfowl.

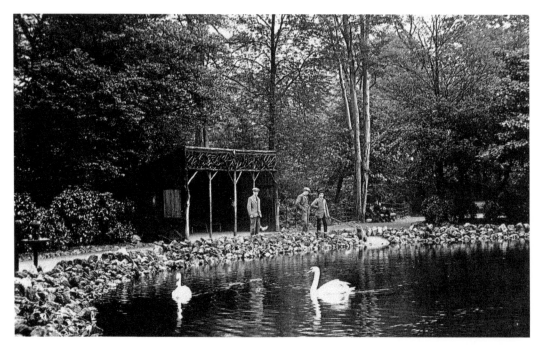

Clifton Park Lake

Mute swans glide on the lake in Clifton Park. A new feature was the ornamental shelter for visitors.

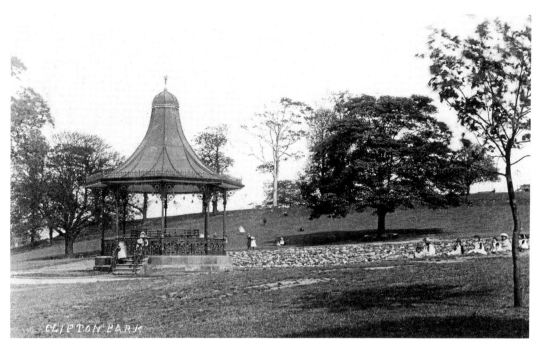

The First Bandstand in Clifton Park

The classical temples built in private landscaped parks in the eighteenth century were reincarnated as bandstands in public parks in the nineteenth century. The first bandstand, as shown here, stood in Clifton Park until 1919 when it was removed to Ferham Park.

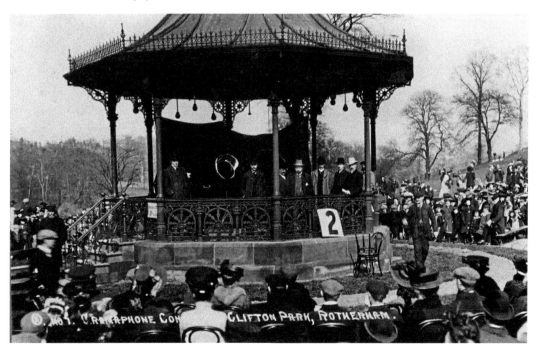

Gramophone Concert, Clifton Park

A large crowd at Clifton Park listen to a gramophone concert being performed in the first bandstand.

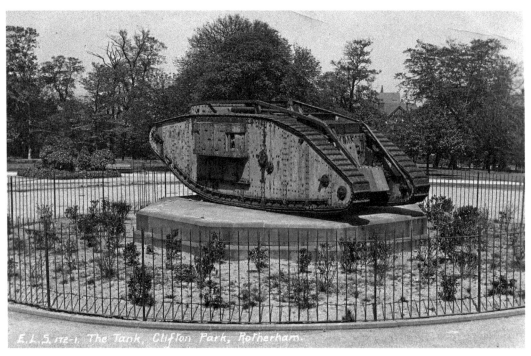

Tank, Clifton Park

This First World War tank occupied the site of the first bandstand until 1927.

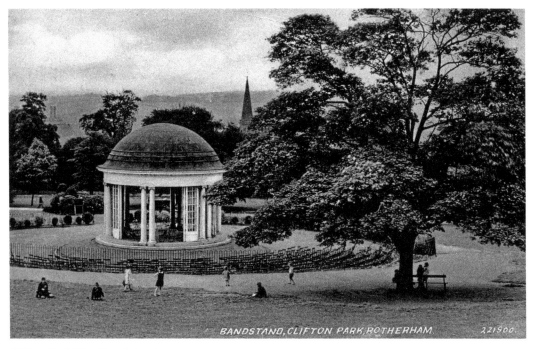

Clifton Park New Bandstand

A new bandstand, as shown here, was erected in 1928. It was refurbished in 1991 to mark the centenary of the opening of Clifton Park.

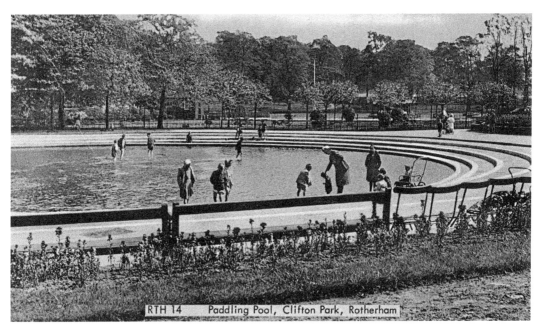

Paddling Pool, Clifton Park

The paddling pool in Clifton Park replaced the lake in 1939, because the latter was believed to be insanitary.

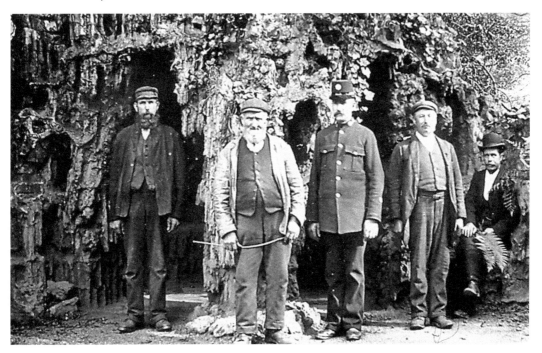

The Grotto, Clifton Park

In an article in the *Rotherham Advertiser* on 6 June 1891, two weeks before the official opening of Clifton Park, the grotto in the park was described as a miniature cave with stalactites hanging from the roof and the interior and exterior studded with corals, fossils and shells.

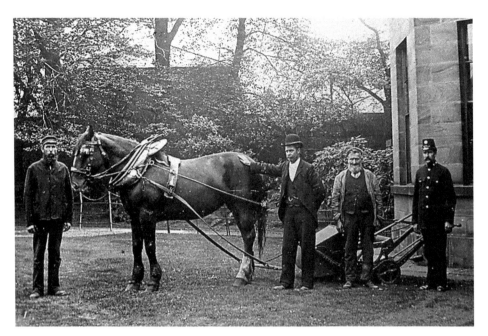

Horse-Drawn Lawnmower, Clifton Park

Garden staff line up with a horse-drawn lawnmower in Clifton Park. Invented in 1830 the lawnmower replaced the scythe for cutting grass. The gentleman looking like a policeman must be a park-keeper employed to keep public order.

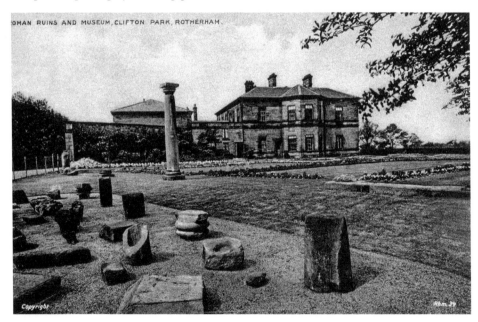

Roman Remains from Templeborough

Roman remains from the granary at Templeborough Roman fort are a unique feature of Clifton Park. They were discovered during an archaeological excavation carried out by Thomas May in 1916–17 before the site was occupied by Steel, Peech & Tozer's melting shop at their Templeborough Steelworks.

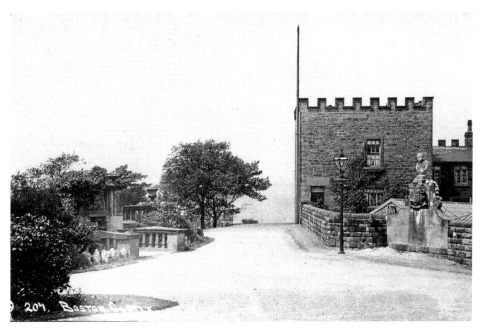

Boston Castle

Boston Castle was built on behalf of the Earl of Effingham in 1773 as a hunting lodge. It was called Boston Castle to commemorate the Boston Tea Party, when 300 chests of tea were dumped in the harbour at Boston, Massachusetts, as a result of heavy tea taxes imposed by the British government. Effingham believed the war against the colonists was unjust.

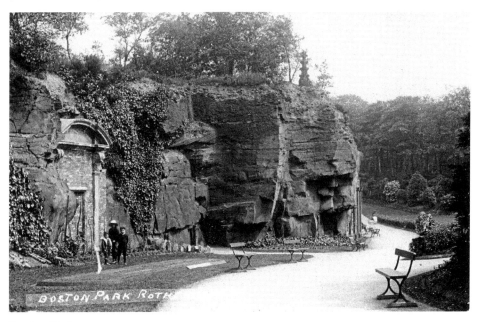

Boston Park

This view in Boston Park shows the re-erected doorway from the fifteenth-century College of Jesus. Boston Park was opened on 4 July 1876 on the centenary of the Declaration of American Independence.

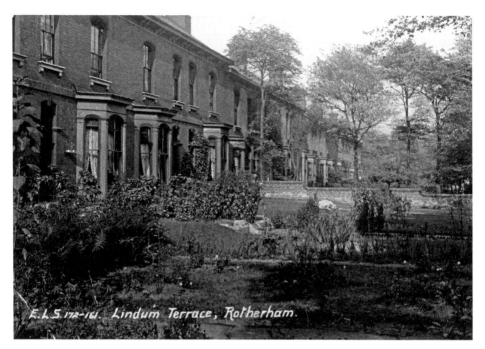

Lindum Terrace

This short row of houses stands just across the road from the entrance to Clifton Park along the tree-lined Doncaster Road. It was built in the 1860s and is an early example of the middle-class residential expansion of the town to the east of the old town.

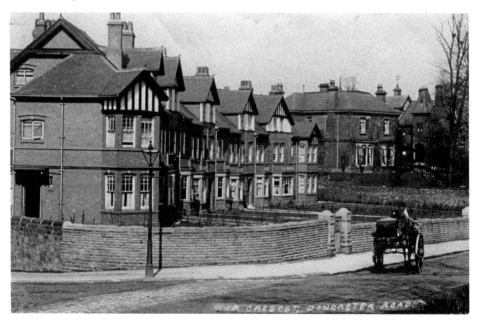

The Crescent, Doncaster Road

This is a further example of the late Victorian and Edwardian residential expansion of Rotherham. This is The Crescent on Doncaster Road, just beyond Lindum Terrace. The half-timbered look in the upper storeys was popular at this time.

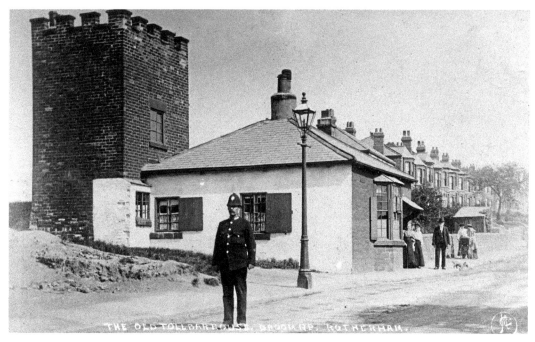

The Old Toll House, Broom Road

The toll house, with jutting-out windows on the roadside to keep an eye on approaching traffic, was built in 1826 on the Rotherham to Barnby Moor turnpike road. It was demolished in 1928. No one knows what the function of the square tower behind the toll house was.

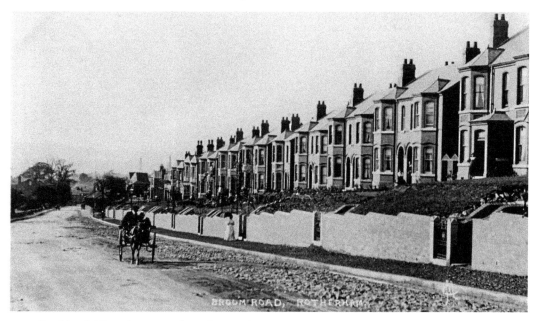

Residential Development along Broom Road

On the OS 25-inch map published in 1893, apart from a short terrace at the western end, this road had farmland to the south and the short-lived Rotherham racecourse to the north. By the time the OS 25-inch map was published in 1923 there was housing on both sides of the road.

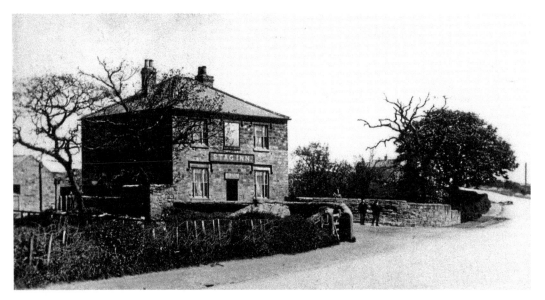

The Stag Inn
The still surviving Stag Inn stands at the intersection of Herringthorpe Valley Road and Wickersley Road on the busy route between Rotherham and Bawtry.

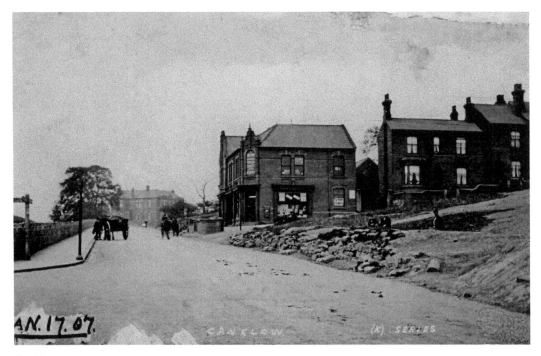

Canklow
This early twentieth-century postcard is labelled 'Canklow', which on early OS maps covered an area on both the Whiston and Brinsworth sides of the River Rother near Rotherham Main Colliery. The street on the right is the bottom of Atlas Street, built by John Brown to accommodate Rotherham Main miners and their families. It was called Atlas Street after the name of John Brown's steelworks. All the old houses, except for two, have now been replaced.

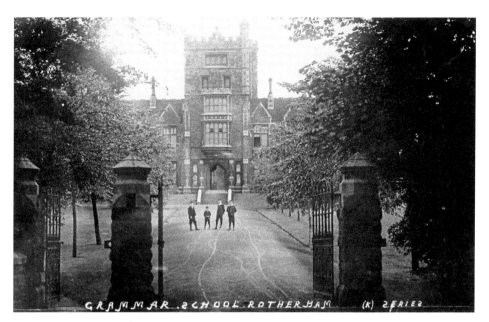

Rotherham Grammar School

The school was founded in 1482–83 by Thomas de Rotherham, Archbishop of York. The building shown here, which still stands, was constructed in 1876 as a training college for ministers of the Congregationalist church. It was purchased in 1890 to house the grammar school for boys. It became the Thomas Rotherham College in 1967.

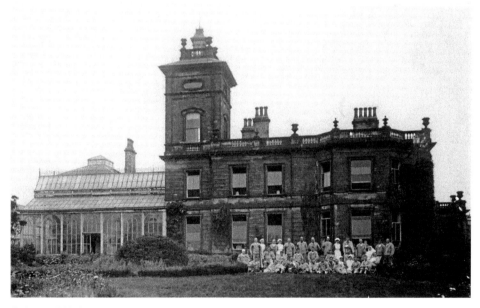

Oakwood Hall

Oakwood Hall was built by James Yates – the stove grate manufacturer – for his family in 1859. He died in 1881. During the First World War it became a hospital for servicemen, then after the war it became a TB sanatorium, as shown here. It now houses the offices of the Rotherham NHS Foundation Trust.

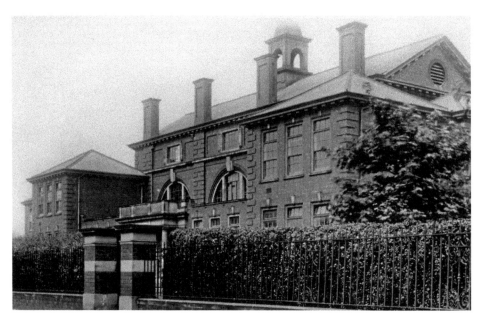

Rotherham Girls' High School

The school began as a private school in Elmfield House in Alma Road. In 1902, when local education authorities were established, it was acquired by the Corporation, who bought a field and built a new school for 300 girls, as shown here in Middle Lane, that opened in 1910. It closed in 1973 when Thomas Rotherham College became co-educational. The building now forms the hub of the renovated and extended Clifton Community School.

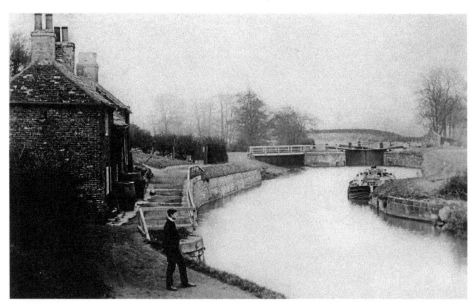

Jordan Lock

We return where we began this chapter, on the Masbrough side of the River Don, this time at the Jordan Lock on the Don Navigation. The development of better communications, first the canals and then the railways, opened up a more reachable national (and international) market for Rotherham's manufacturers.

3

Surrounding Rural and Industrial Settlements

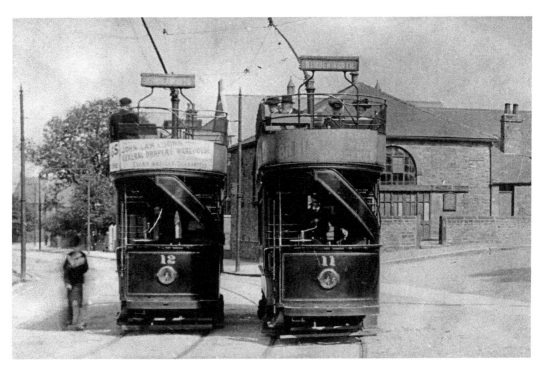

The Tramway System

The town of Rotherham (including Masbrough) is surrounded on all sides by villages, hamlets, farmsteads, isolated cottages and the mansions built for the aristocracy, the gentry and wealthy industrialists. On 31 January 1903 a new public transport system welded the settlements closer together. On that date the first tram travelled from the town along the lines to Fitzwilliam Road and Rawmarsh Road. The photograph shows two trams on the Rotherham to Kimberworth route, the one on the left advertising John Law's General Drapery Warehouse.

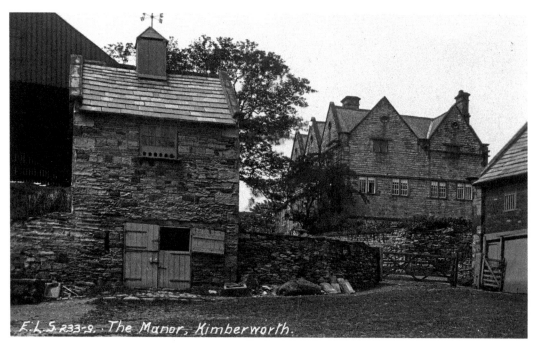

Kimberworth Manor House

The manor house was built for the Kent family in 1694. The small building in the foreground is a dovecote, a privilege of the rich landowners. The pigeons were valued for their meat, eggs, feathers and dung. The house and dovecote have survived.

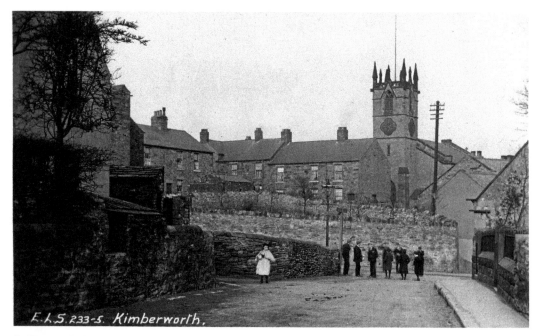

St Thomas's Parish Church, Kimberworth

Kimberworth did not have a medieval parish as it was part of the extensive parish of Rotherham. The foundation stone of St Thomas's was laid in 1841 and consecrated in 1843. The tower was added in 1860.

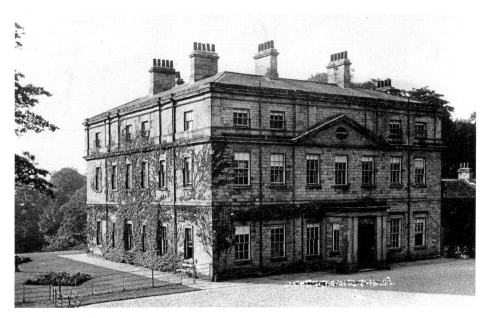

Thundercliffe Grange

This mansion was built between 1776 and 1783 by John Platt, the local mason-cum-architect for the Earl of Effingham. The earl's mansion at Holmes Hall was becoming uninhabitable because of Rotherham's industrial expansion. Successive earls of Effingham resided at Thundercliffe until 1860.

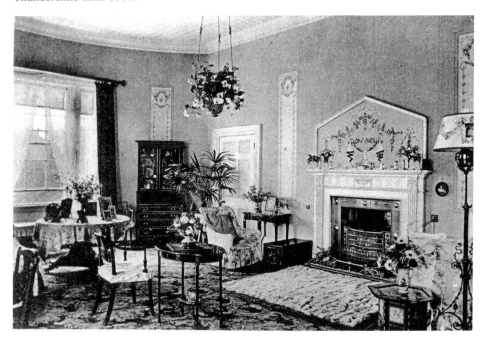

The Drawing Room, Thundercliffe Grange

From the 1890s until the 1980s Thundercliffe Grange was successively a sanatorium for female psychiatric patients and a children's hospital. It is now divided into apartments. The photograph shown here appeared in a prospectus in the early 1900s.

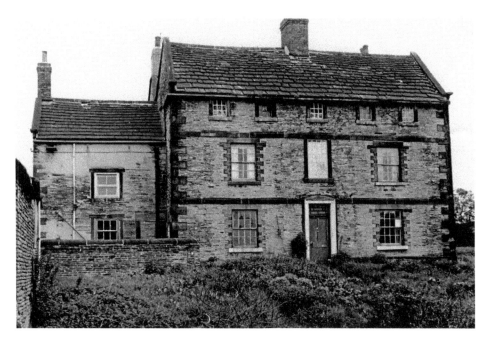

Barley Hall

Barley Hall in the second half of the eighteenth century was the home of John Johnson, who converted to Methodism in 1740. John Wesley, 'the Father of Methodism', was a regular visitor, but not always welcome locally. On one occasion opponents of the new denomination tarred and feathered a horse simply because it had been used to carry a Methodist preacher from Thorpe Hesley to Rotherham! Barley Hall has since been demolished.

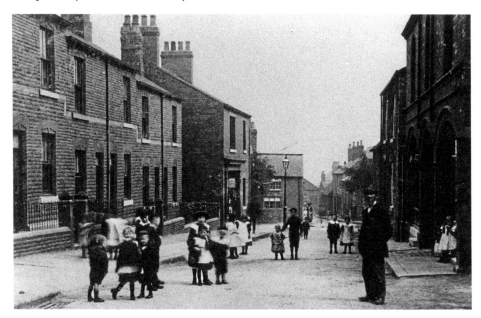

Thorpe Street, Thorpe Hesley

Thorpe Street is shown in the 1920s. The buildings with their gable ends at right angles to the street gave it its local name, Gable Ends.

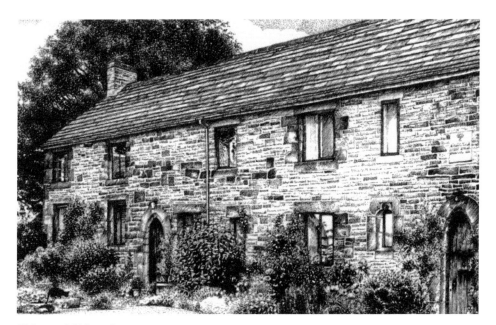

Kirkstead Abbey Grange

The Grange is the much-altered descendant of the headquarters building of a grange built by the monks of Kirkstead Abbey in Lincolnshire following a grant of land by the Norman lord Richard de Builli in 1161. The monks were given permission to mine ironstone and make iron, using two furnaces and two forges.

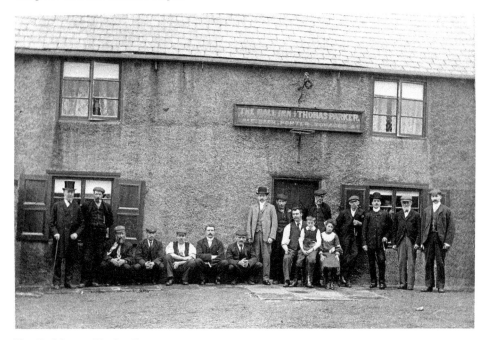

The Ball Inn at Hesley Bar

This scene was taken in the early years of the last century. The landlord, Thomas Parker, sits in the middle of the group with two of his children. Thorpe Hesley was a mining village and five of the regulars are adopting the 'miners' squat' for the photographer.

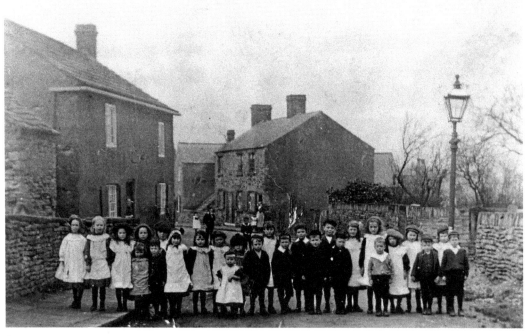

Scholes Village

Smartly dressed village children line up for the photographer in Scholes in 1906. In 1891, out of a working population in the village of 102, no fewer than eighty-eight were coal miners. It is now called 'Millionaire's Row' by some people!

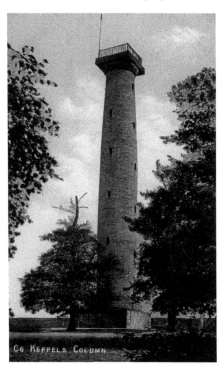

Keppel's Column

This monument was built on the extreme southern boundary of the Wentworth estate. It was begun in 1773 and completed in 1780. It was a monument to the 2nd Marquis of Rockingham's political ally, Admiral Keppel. It used to be open to the public on payment of one penny and then you could climb the 217 steep steps to the top.

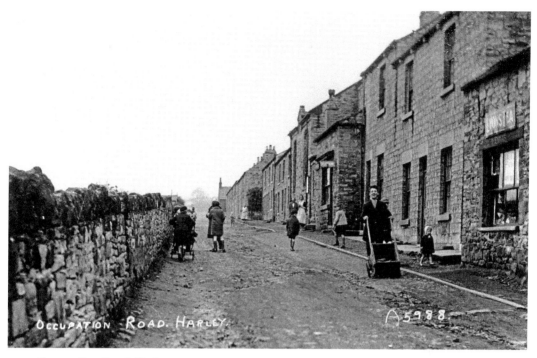

Occupation Road, Harley

Harley was and still is a small settlement, now on the extreme western boundary of the metropolitan borough. Note the unmade road and the boy with the barrow, known locally as a 'drug'.

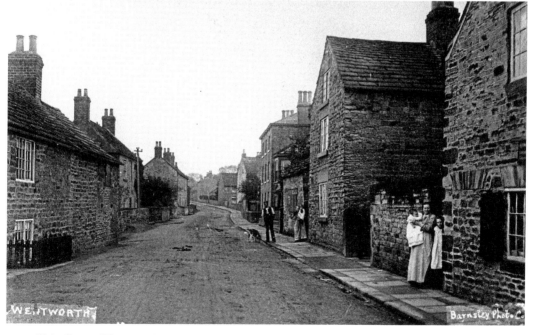

Main Street, Wentworth

Wentworth is probably the best example in South Yorkshire of a street village, with the houses, in the past inhabited by Wentworth estate tenants and employees, arranged on both sides of the main street.

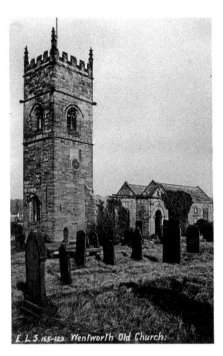

E.L.S.165-123. Wentworth Old Church.

Wentworth Old Church

The church is medieval and the last service took place there on 29 July 1877. A tour of the graveyard reveals details of former estate employees carved on their gravestones.

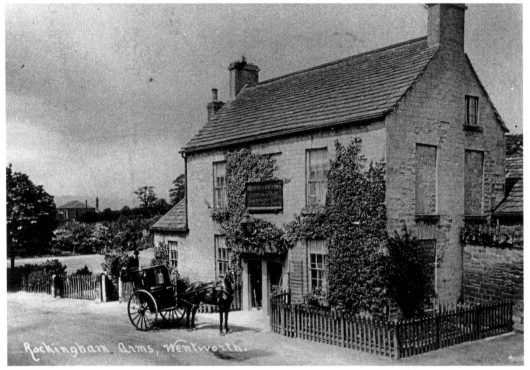

Rockingham Arms, Wentworth.

The Rockingham Arms, Wentworth Village

The name of this public house relates to the title adopted by Thomas Watson-Wentworth when he became the 1st Marquis of that name in 1746. His grandmother was Lady Rockingham of Rockingham Castle in Northamptonshire.

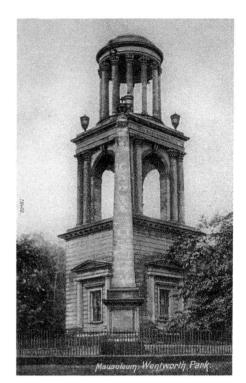

The Mausoleum, Wentworth Park

The mausoleum is to the 2nd marquis of Rockingham, who was prime minister twice and died in office in 1782. It is not a mausoleum in the true sense because the Marquis was buried in York Minster. Inside is a statue of the marquis dressed as a Roman senator.

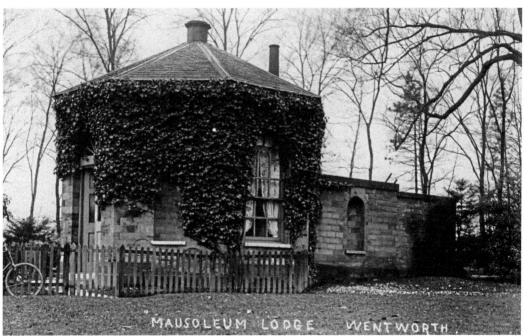

The Mausoleum Lodge, Wentworth

This lodge was built to house the custodian responsible for the safekeeping of the mausoleum and its contents, which contained not only the statue of the 2nd Marquis but also the busts of his eight closest political allies.

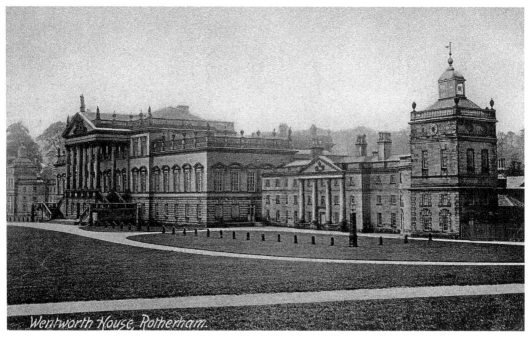

Wentworth House, Rotherham.

The Palladian East Front of Wentworth Woodhouse

Wentworth Woodhouse was the ancestral home of the marquises of Rockingham and the earls Fitzwilliam. The east front was begun in 1732 and was still unfinished as late as 1772. It is the longest country house in England, measuring 606 feet (183 metres).

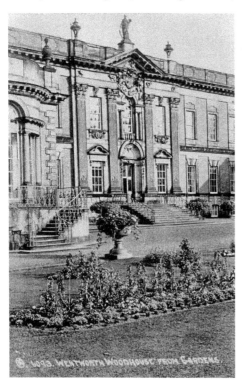

WENTWORTH WOODHOUSE FROM GARDENS

The West or Garden Front, Wentworth Woodhouse

Wentworth Woodhouse is a back-to-back house. This is the west or garden front, which is attached to the east front. It was begun in 1724 and completed in 1734. It is in the baroque style, a much more exuberant style than the more restrained style of the Palladian east front.

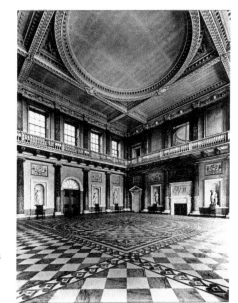

The Marble Saloon, Wentworth Woodhouse
This was the grand reception room where balls, christenings, coming-of-age celebrations and weddings were held. In the niches around the walls are statues purchased by the 2nd Marquis of Rockingham in Rome while on his 'grand tour'.

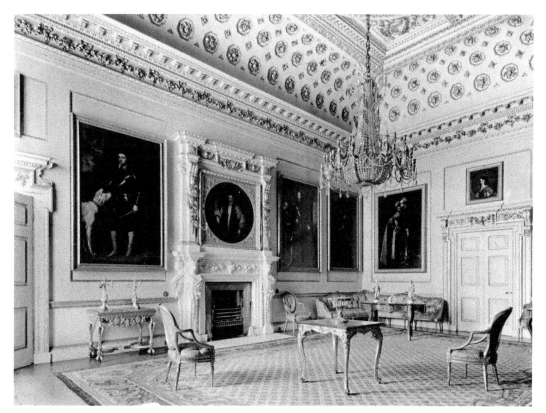

The Van Dyck Room, Wentworth Woodhouse
This was so-called because of the paintings by the Dutch artist Anthony van Dyck on the walls. To the left of the fireplace is a full-length portrait of the 1st Earl of Strafford, who was beheaded for treason in 1641.

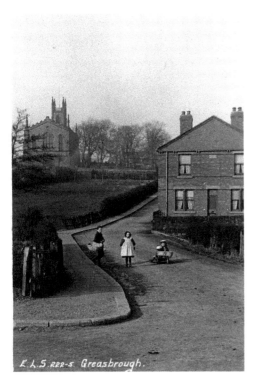

Greasbrough

The village of Greasbrough came within direct influence of the Watson-Wentworths and their successors, the earls Fitzwilliam. The heir to the earldom (Viscount Milton) laid the foundation stone to the church and a public house in the village is still called the Lord Milton.

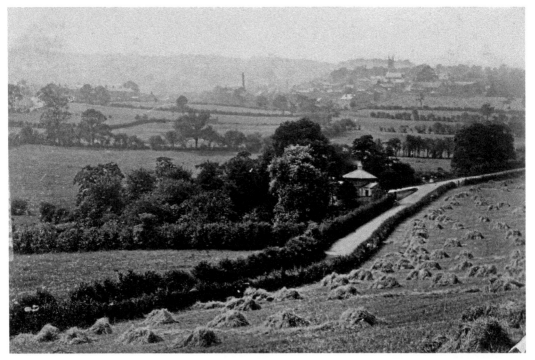

A View Towards Greasbrough

A view across the fields on either side of Cinder Bridge Road looking towards Greasbrough with its church tower just visible on the horizon. The small building in the middle is Glossop Lodge.

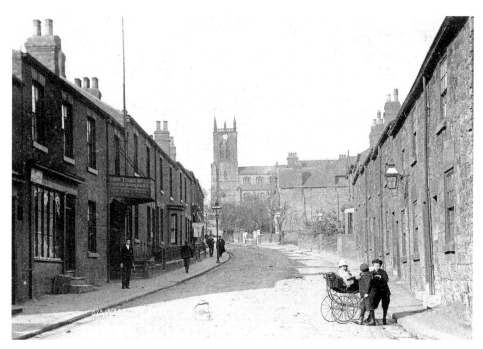

Rawmarsh Hill

It is interesting that Rawmarsh, whose name incorporates the word marsh, is partly on a hill, Rawmarsh Hill, as shown here. But to the east is the wide floodplain of the River Don, which, when the settlement was founded, would have been marshland.

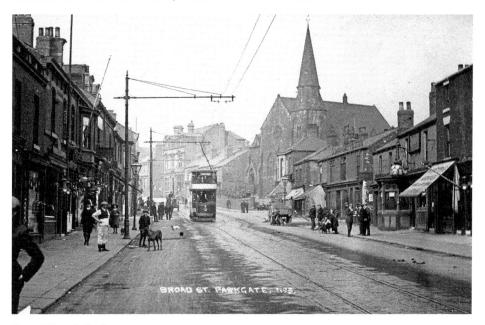

Broad Street, Parkgate

Parkgate grew up in the nineteenth century to the south of Rawmarsh as an industrial satellite. Its creation and subsequent growth was mostly the result of the opening of Park Gate Iron and Steel Works and Aldwarke Colliery.

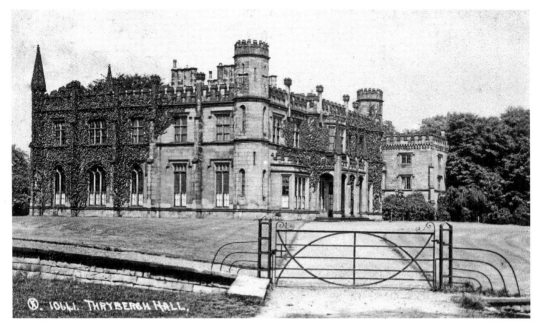

Thrybergh Hall

The castellated Thrybergh Hall is of late Georgian date (*c.* 1820). It was built for the head of the Fullerton family. It is now the clubhouse for Rotherham Golf Club, which was founded in 1903. The golf course itself is in the surrounding parkland, which was once a deer park.

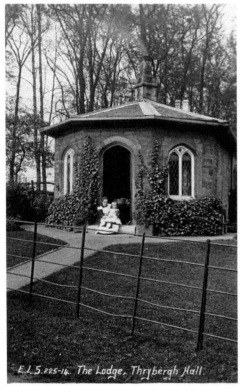

The Lodge at Thrybergh Hall

The ivy-clad lodge stands at the entrance to Thrybergh Park. Park gate lodges were designed to house porters or gatekeepers who were paid to guard the estate and open and close gates. It has been estimated that there may be as many as 10,000 park gate lodges surviving across the country.

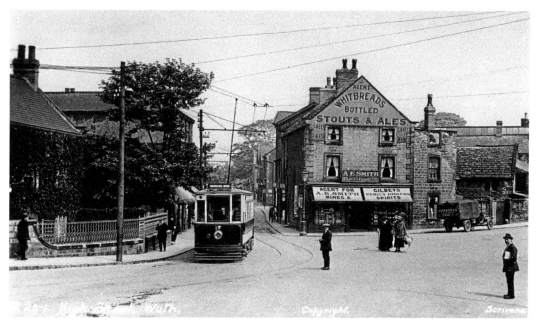

High Street, Wath upon Dearne in the 1920s

The tram service started running in 1923. The shop facing the camera is A. E. Smith's family grocery and beer and wine store. The building occupied by the store was once the village candle-making factory.

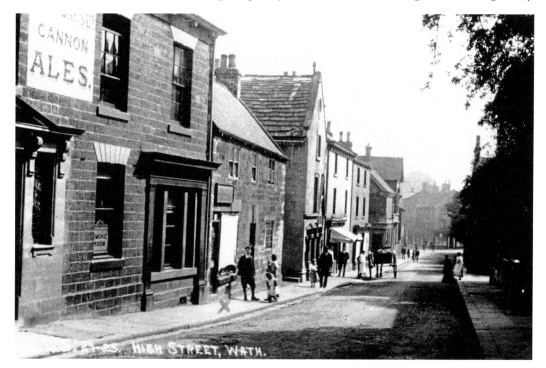

Another View of High Street, Wath

This was the heart of the retail area of the small town that grew enormously with the opening of Manvers Main and Wath collieries.

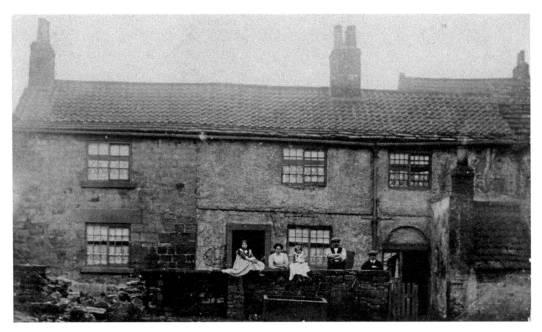

The White Family at Hall Farm, Kilnhurst

Despite heavy industrialisation in the nineteenth century, 60 per cent of Rotherham Metropolitan Borough is still countryside with many working farms.

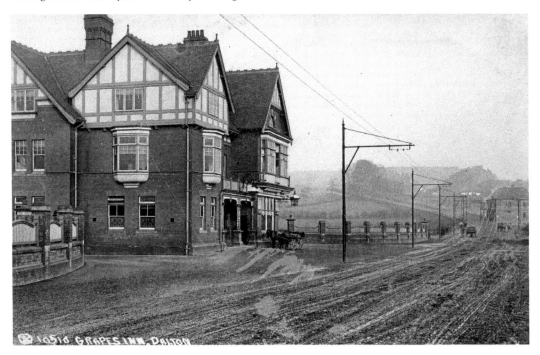

The Grapes Inn, Dalton

In the first decade of the twentieth century, Joe Steeples was the landlord here. Mainly as a result of the opening of the nearby Silverwood Colliery in 1905, the population of Dalton grew from 438 in 1901 to 3,248 in 1911.

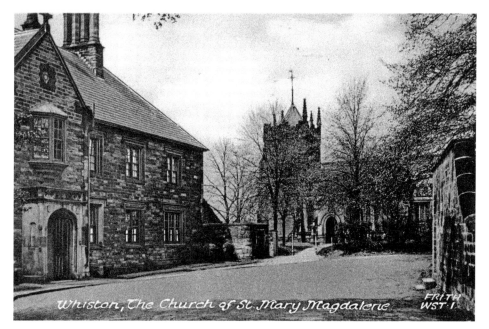

Whiston

The modern village of Whiston is entirely on low ground but the old village climbs up a steep hill with the parish church on top. The church is mostly Victorian but the tower is Norman. The old rectory, shown on the left, is now converted into offices.

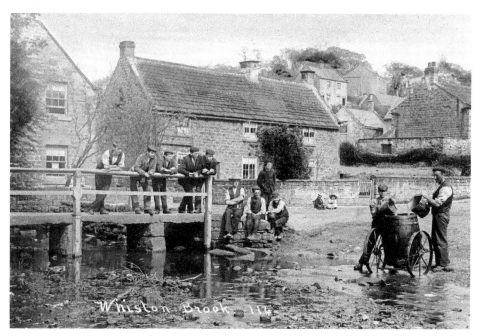

Whiston Brook

Running through the lower part of the old village of Whiston is the brook that in former times provided the village's water supply. On the right a wheeled water barrel is being filled, watched by an interested group of villagers.

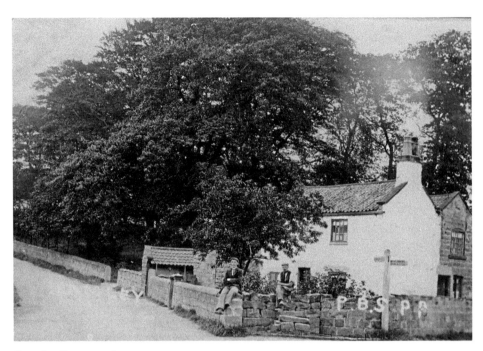

Bramley Crossroads
Two locals pose for the photographer on the wall at Bramley crossroads. The signpost indicates that the road to the right leads to the village of Micklebring and on to Doncaster.

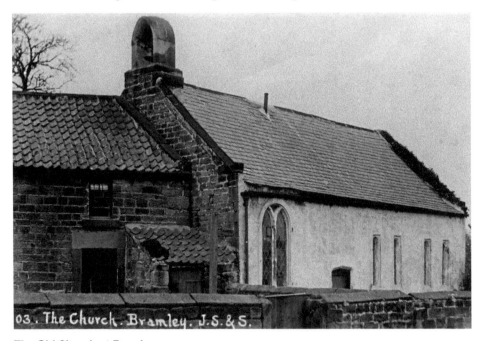

03. The Church. Bramley. J.S. & S.

The Old Church at Bramley
This old church was demolished in 1956. It was of unknown date but a church was recorded in the village in the Domesday Book (1086). It only held around fifty people and did not have a license for marriages until 1949. A new church dedicated to St Francis was built in 1955.

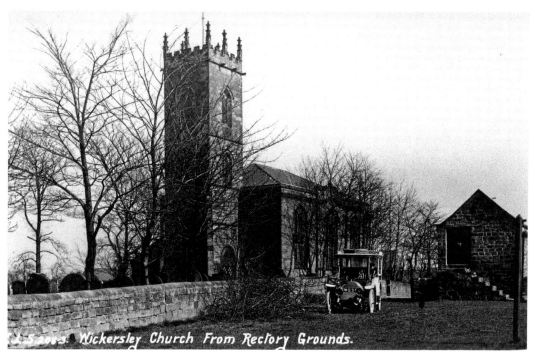

St Alban's Church, Wickersley

Still situated down the quiet Church Lane, the church is dominated by its grand tower, the base of which is in the Perpendicular style. The nave and chancel are early and late nineteenth century respectively.

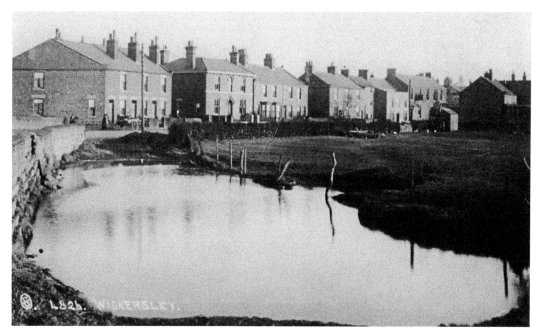

The Pond Beside Bawtry Road, Wickersley

Unfortunately the pond is long gone. Situated just 3 miles from the centre of Rotherham, Wickersley became quickly suburbanised and this included the exclusive Listerdale residential development.

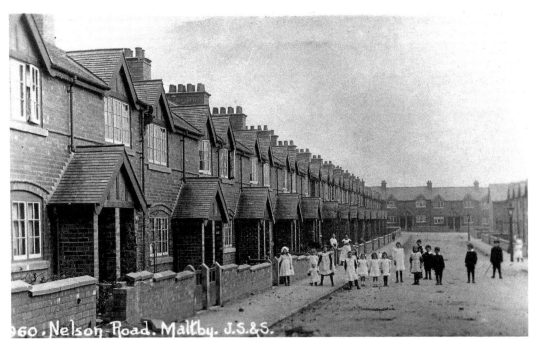

Nelson Road, Maltby

Nelson Road was part of an extension to the north of Tickhill Road of the 'model village' developed to accommodate miners and their families after the opening of Maltby colliery in 1911. This small residential estate began to be built in 1912 and had streets named after British admirals, becoming known as the 'Admirals' Estate'.

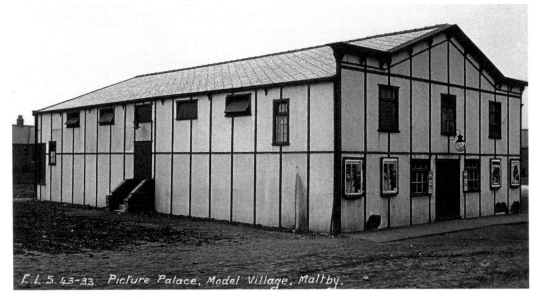

The Picture Palace, Maltby

This cinema opened around 1920 at the top of Muglet Lane. The 1911 census recorded that there was already a 'bioscope operator' living in the model village. A bioscope is an old name for a cinema film. He must have shown films in places like the church hall or the miners' institute.

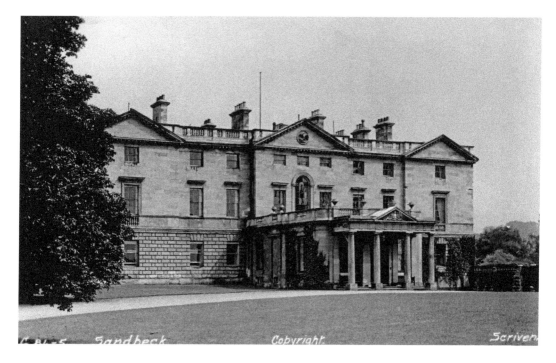

Sandbeck Hall, Home of the Earl of Scarbrough

The mansion was built between 1762 and 1770 by James Paine for the 4th Earl. The architectural historian Nikolaus Pevsner said this country house was one of Paine's most dramatic designs.

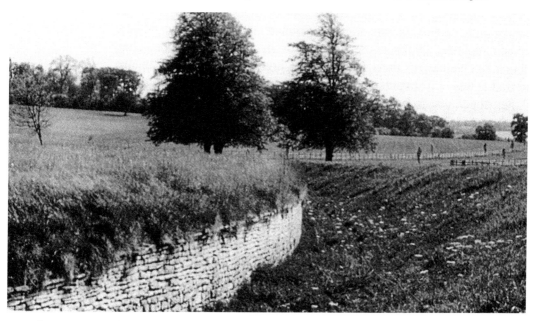

Sunk Fence in Sandbeck Park

The 4th Earl of Scarbrough entered into a contract with Lancelot 'Capability' Brown in September 1774 to re-landscape the park and the valley up to the ruins of Roche Abbey. The sunk fence, or ha-ha, shown here was part of Brown's landscaping work.

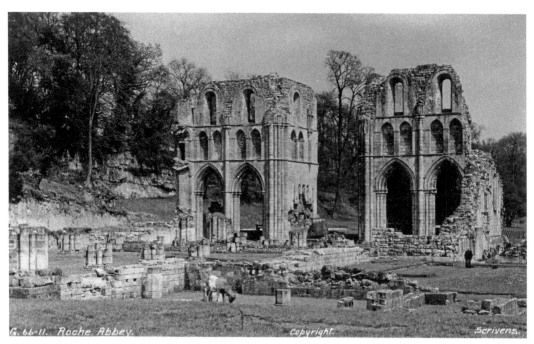

Roche Abbey

The Cistercian Roche Abbey was founded in 1147 and dissolved in 1538. Capability Brown covered up most of the ruins during his landscaping of the site. These have now been fully exposed to reveal the full abbey layout.

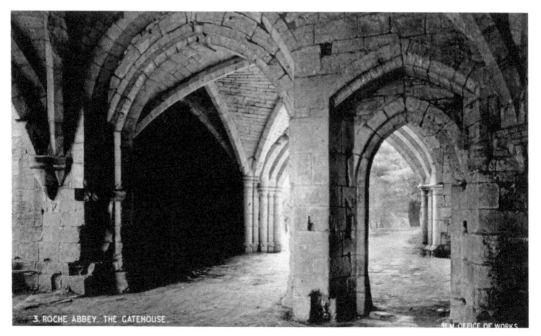

The Gatehouse, Roche Abbey

This evocative photograph shows the beautifully preserved vaulted gatehouse at Roche Abbey. The wide entrance was for those arriving or departing in a carriage and the narrow one was for pedestrians.

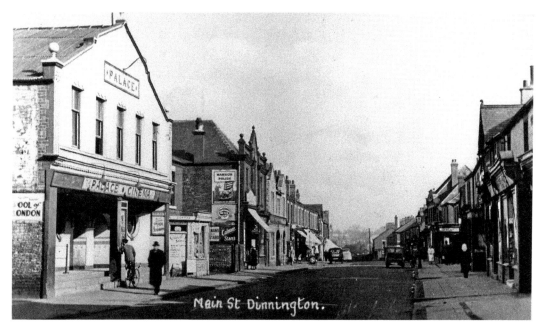

Main Street, Dinnington

In the left foreground is the Palace Cinema, which was built around 1915. It closed in the early 1960s and was converted into a superstore. The building is now occupied by a pharmacy and a ladies' clothes shop.

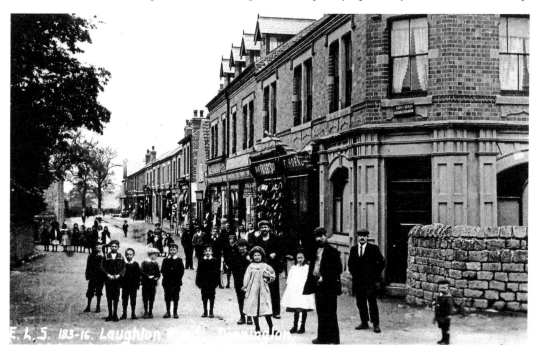

Laughton Road, Dinnington

A street scene from around 100 years ago, with the usual gang of children in attendance. Laughton Road contained a wide range of shops at that time. In the foreground the barber's pole of Fred Horne's hairdresser's shop can be seen.

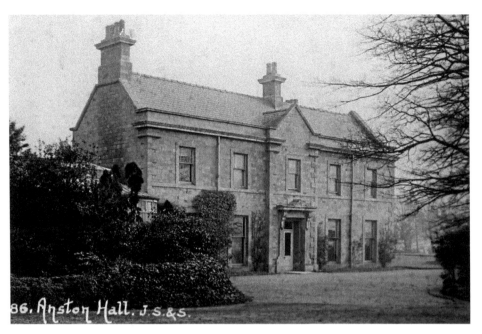

Anston Hall

The Wright family came to live at Anston in the seventeenth century, establishing an estate centred on Anston Hall. In the 1881 census it was recorded that Charles Wright and his wife had nine servants. Charles Wright's daughter, Constance, sold the estate in 1947 and the hall was converted into apartments.

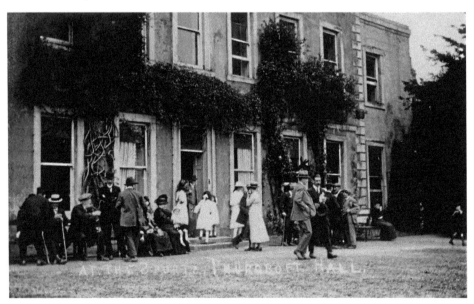

Thurcroft Hall

The hall was built in 1699 and refurbished in the late eighteenth century. The hall and surrounding estate was bought in the nineteenth century by Thomas Marrian. It was his son who leased the estate lands to the Rothervale Colliery Co. in 1902, leading to the sinking of Thurcroft Colliery. The hall is now a Grade II*-listed building.

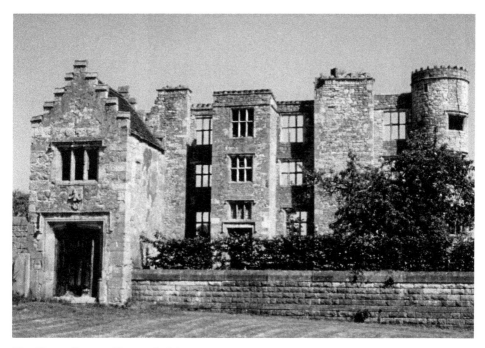

The Manor House, Thorpe Salvin

The impressive south wall is all that remains of Thorpe Salvin manor house, built by Henry Sandford in the 1570s. When his ancestor Brian Sandford established a deer park there in 1491–92 he was given a gift of twelve does (female fallow deer) from the king's park at Conisbrough.

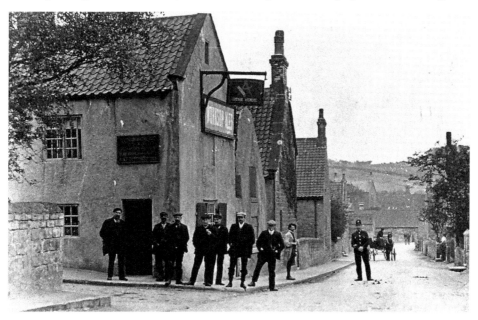

The Square and Compass, Harthill

Some customers pose outside the old Square and Compass public house (now no more) in Harthill. Harthill is the most southerly village in Rotherham Metropolitan Borough, the centre of the village being around a mile from the border with Derbyshire.

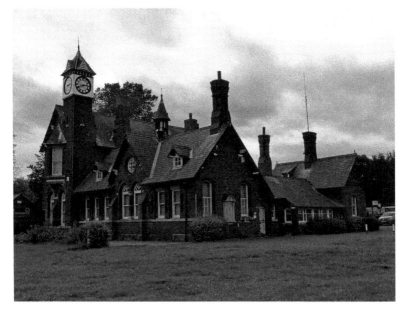

Kiveton Park Colliery Offices

The colliery offices, with a tall clock tower and built in 1872, are a reminder of Kiveton Park's mining past. Despite the closing of the colliery in 1994, the building has been refurbished and is now a community centre. The clock in the clock tower still tells the right time.

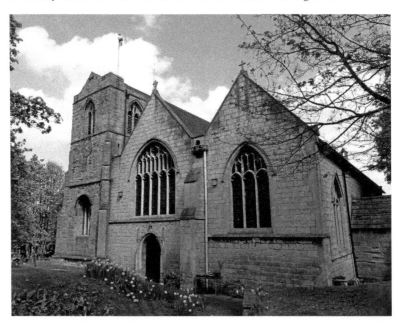

St John the Baptist Church, Wales

This Norman church has dominated the village of Wales for centuries. It is constructed of attractive stone rubble, of varying proportions up to boulder-size, and has a Perpendicular-style west tower. It was enlarged in 1897. The village, whose Anglo-Saxon name means 'The Welshmen', indicates that there was already a Celtic settlement here when the Anglo-Saxons penetrated the area.

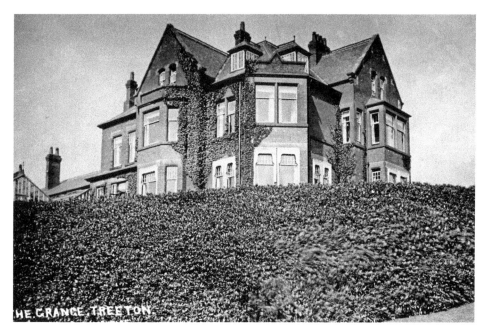

Treeton Grange

This large house was built by Sir Frederick Jones, managing director of Rothervale Collieries Ltd, the owner of nearby Treeton Colliery. It was built outside the village and away from the colliery. It still survives and is now a private care home.

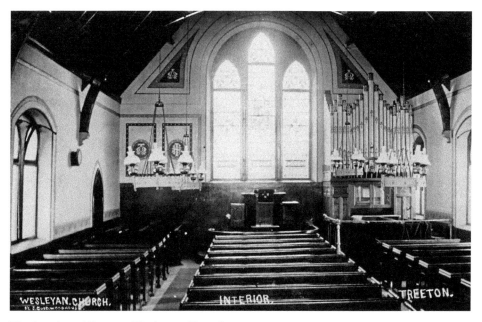

The Interior of Treeton Wesleyan Chapel

Treeton Wesleyan Chapel was built in 1882. The chapel catered for the needs of the many Nonconformists among the migrant miners and their families who had flocked to the village. The colliery was opened in 1878, and between 1881 and 1901 the population of the village more than doubled from 897 to 1,973.

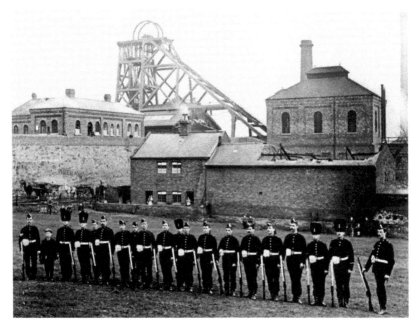

Orgreave Colliery

Troops are shown at Orgreave Colliery during the lockout of miners in 1893. Having refused a 25 per cent reduction in wages the miners were locked out between July and November and mobs attacked colliery premises, which had to be protected by police and the army.

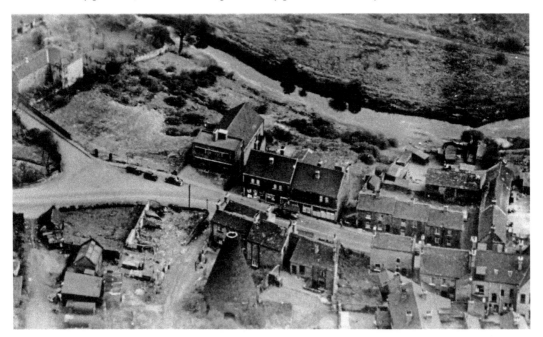

Catcliffe

This aerial view of Catcliffe was photographed in the early 1950s, looking eastwards with the River Rother just beyond the village. In the foreground the eighteenth-century glass kiln built by William Fenney in 1740 can be seen. It is the oldest surviving building of this type in Western Europe.

4

The World of Work

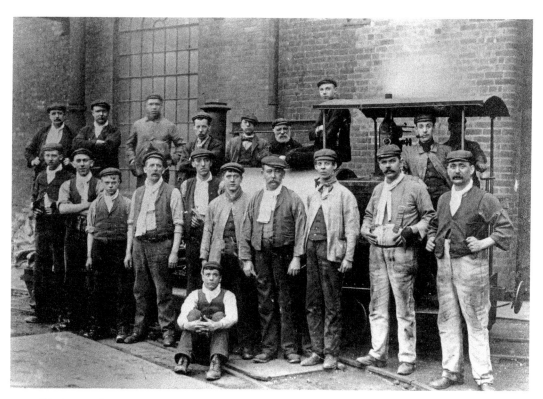

Workers at Park Gate Iron and Steel Works

Whether working the land, mining coal, making iron and steel and other metal products, pottery and glass, the people of Rotherham have over the centuries became renowned for their industry, hard graft and inventiveness. And those engaged in farming or manufacturing were served by a legion of shopkeepers and itinerant tradespeople. Pictured here in around 1910 are workers at Park Gate Iron and Steel Works where, in the 1850s, the armour plate for Isambard Kingdom Brunel's steamship the *Great Eastern* was manufactured.

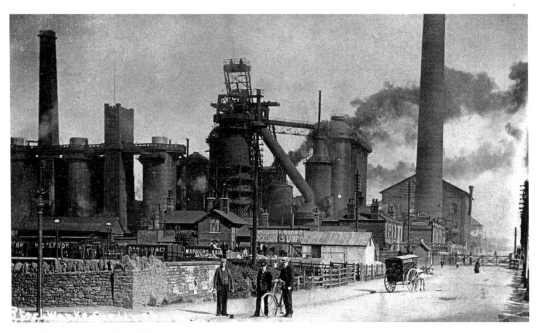

Park Gate Iron and Steel Works

Park Gate Iron and Steel Works was established in 1823 and the first blast furnace was erected in 1839. Its early prosperity was based on the production of rails for the rapidly expanding railway network, but later armour plate was a major product.

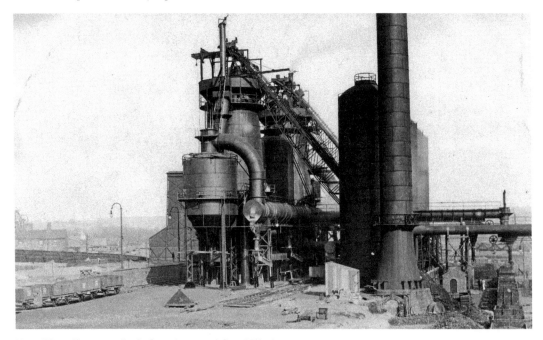

New Blast Furnace, Park Gate Iron and Steel Works

The new blast furnace was erected in 1905. The works played a major role in supplying metal products for the armed forces during the Second World War. The works were demolished in 1976 and the site is now occupied by a new road network and an out-of-town shopping centre.

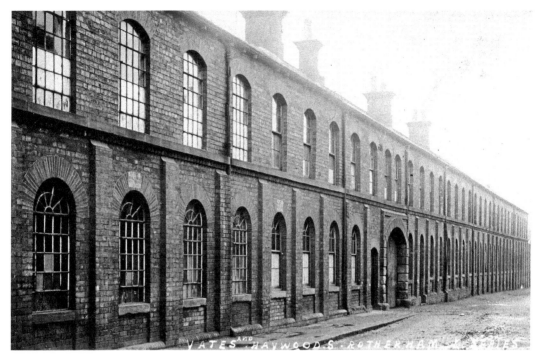

The Effingham Works

Yates & Haywood's Effingham Works, once claimed to be the largest factory in the world, was opened in 1855. The Effingham Works specialised in the manufacture of fireplaces and kitchen ranges. Products were exhibited at the Great Exhibition in 1851. The firm operated for 150 years.

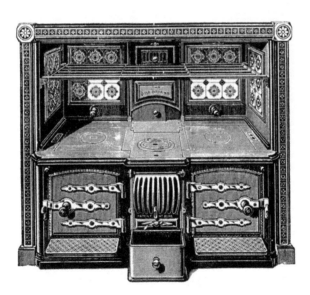

A Yates & Haywood Kitchen Range

Yates & Haywood took advantage of the enormously expanding market for kitchen ranges as Britain's urban and industrial population exploded in the nineteenth century. It was the last of Rotherham's stove grate and fireplace manufacturers, which once numbered more than thirty.

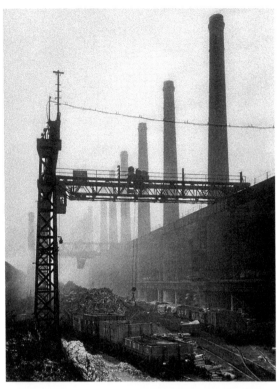

Steel, Peech & Tozer
Shown here is the exterior of Steel, Peech & Tozer's Templeborough steelworks melting shop. Construction began in 1916 and the first of the open-hearth furnaces was tapped the following year to supply shell steel for the armed forces. By the end of the First World War eleven furnaces were in production.

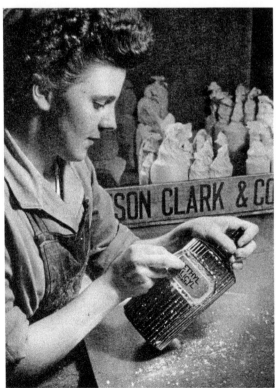

Beatson Clark's Glassworks
Every type of glass container for the food, drink and pharmaceutical industries has been made at Beatson Clark's glassworks: from eye baths and scent bottles to feeding bottles and bottles for the famous Izal disinfectant. Production continues today, nearly 270 years after the establishment of glassmaking on the site.

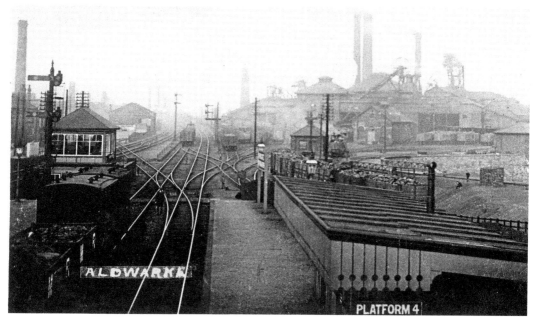

Aldwarke Railway Station

This industrial scene shows Aldwarke railway station with the headgear of the four shafts at Aldwarke Main Colliery in the background. Location near canals and then railways was crucial in the establishment and subsequent expansion of industry in the Rotherham area.

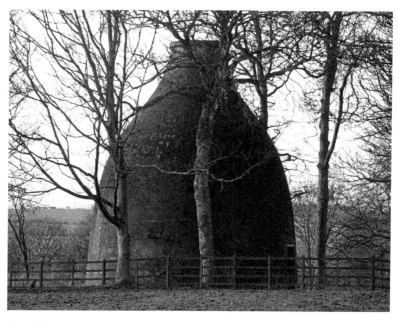

Rockingham Pottery Kiln

This bottle-shaped kiln marks the site of the famous Rockingham Pottery near Swinton. There was a pottery here from 1745 but it only became famous after 1806, when it came into the possession of the Brameld family and was financially supported by Earl Fitzwilliam of nearby Wentworth Woodhouse. It closed in 1842.

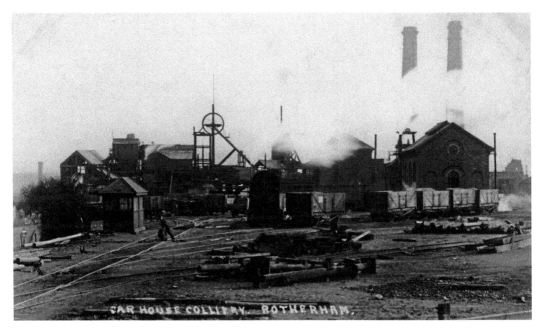

Car House Colliery

This colliery, between Rotherham and Greasbrough, was named after the mansion that stood nearby. The colliery closed in 1920. In 1913 the colliery was flooded and eight miners tragically drowned.

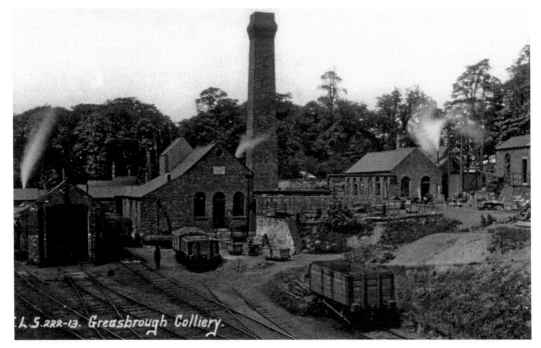

Greasbrough Colliery

Greasbrough Colliery was located on Town Lane to the west of Greasbrough, near Scholes Coppice. A colliery on this site operated from 1850 until 1909. Part of the site is now occupied by a public house, the Kimberworth Park, previously called the Hook, Line and Sinker.

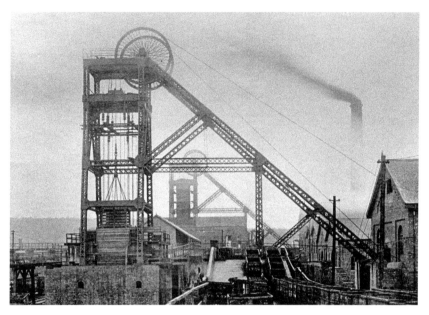

Silverwood Colliery
The prominent headgear of collieries dominated many South Yorkshire villages for more than a century. Silverwood Colliery came into production in 1905 and did not close until 1991. In nearby Dalton, the Silverwood Miners' Welfare building still survives.

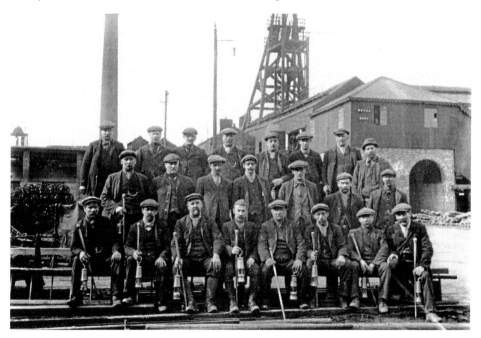

Miners, Manvers Main Colliery
Shown here is a group of pit 'deputies' (identified by their sticks) and other senior employees at Manvers Main Colliery, Wath upon Dearne. Manvers Main consisted of two collieries 650 yards apart, the first coal being raised in 1870. It was later linked underground with other local collieries. The colliery complex closed in 1988.

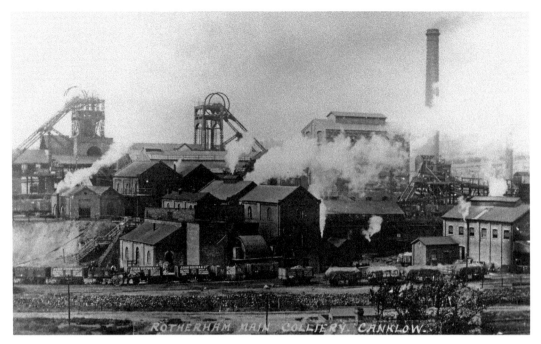

Rotherham Main Colliery

This colliery was sunk in 1876 and gave rise to a completely new colliery settlement called Atlas Street in Brinsworth to the east of the colliery.

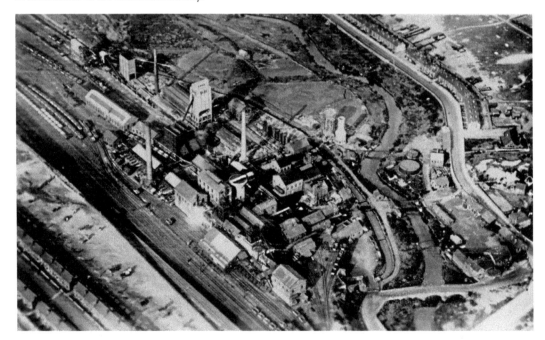

Aerial View of Rotherham Main Colliery

This aerial view is looking north-east. To the east of the colliery the meandering River Rother can be seen and beyond that a row of houses built for senior employees at the colliery. A few of the houses in Atlas Street can be seen in the bottom left-hand corner of the photograph.

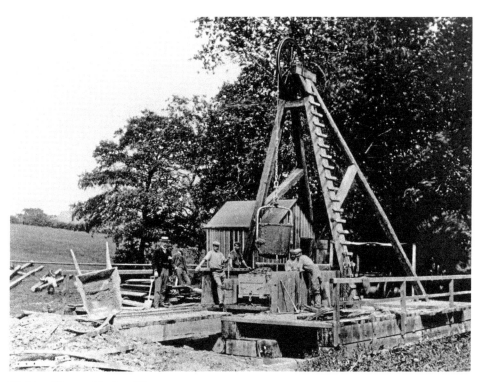

Sinking Thorpe Hesley Pit

Sinking took place between 1901 and 1903. This colliery was not connected to a railway and coal was not wound to the surface here. It was a ventilation, service and water pumping shaft for other collieries owned by Newton Chambers.

Another View of the Sinking of Thorpe Pit

The colliery closed in 1972 but had an unusual function on two occasions after that. It was used as the location for the Disney feature film *Escape from the Dark* and for the outdoor scenes of the BBC adaptation of Barry Hines' *The Price of Coal*.

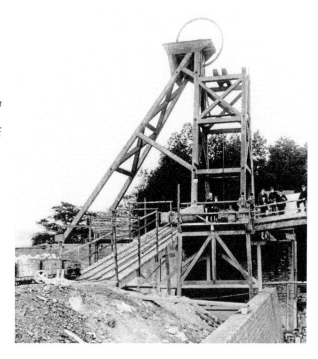

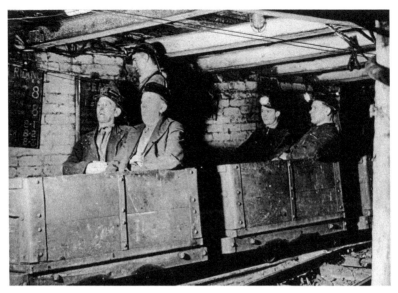

A Pit Paddy
Miners ride in the pit paddy (underground miners' train) at Roughwood Drift at Grange Colliery.

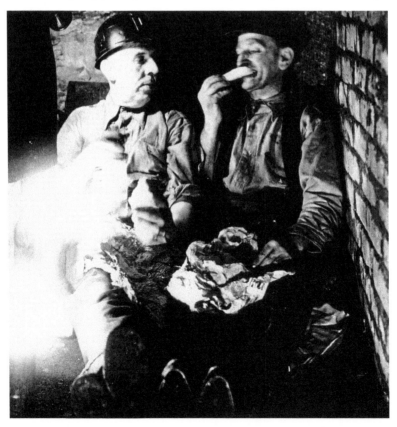

Miners Having Their 'Snap'
George Barker and Ben Copley eating their 'snap' (packed lunch) at Grange Colliery.

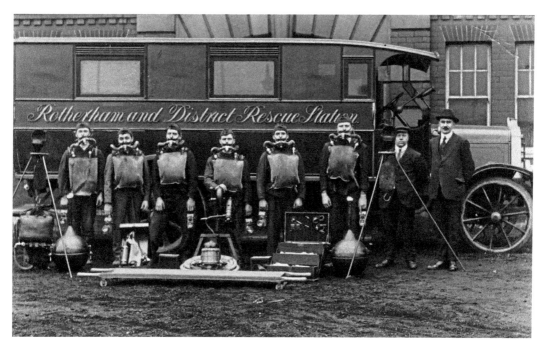

Rotherham District Mine Rescue Station Team
The team pose beside their vehicle, ready for action. They could be called into action at any one of a dozen large collieries operating in the Rotherham area in the early twentieth century.

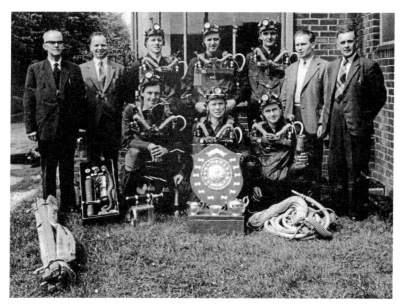

The Barley Hall Mines Rescue Team, Thorpe Hesley
This photograph dates from the 1960s. Back row, from left to right: Mr Webb (superintendant, Rotherham Mines Rescue Station), Mr R. Goddard (group manager), Mr T. Bintcliffe (vice-captain), Mr E. Mollett, Mr R. Bamforth, Mr G. King (colliery under-manager) and Mr W. Firth (colliery safety and training officer). Front row: Mr R. Sidebottom (with canary), Mr C. Willoughby (captain) and Mr D. Smith.

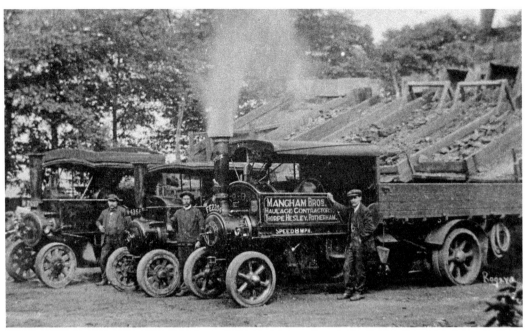

Mangham's Coal Lorries at Scholes Colliery
Bert and Leonard Mangham's coal lorries are probably being loaded at their father's (Arthur Mangham) Scholes Colliery. One of the markets for Scholes Colliery's coal was Rotherham power station.

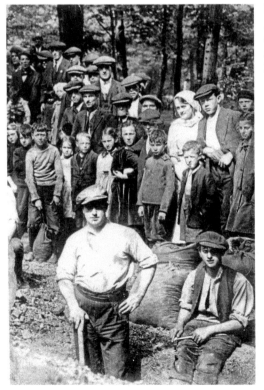

Digging for Coal During the 1926 Strike
Miners in Hesley Wood, Thorpe Hesley, dig for coal during the 1926 coal strike, watched by a large group of villagers. The miners' strike lasted for six months.

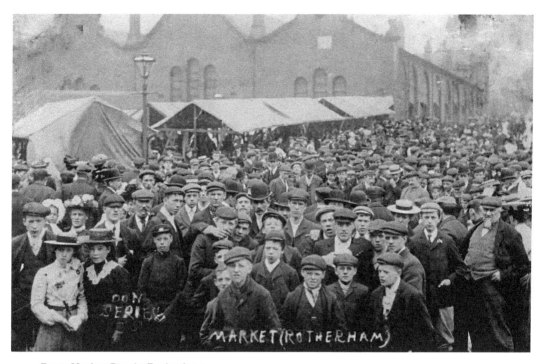

Busy Market Day in Rotherham

Rotherham is an ancient market town. The fact that Rotherham was granted the right to hold a fair by King John in 1207 suggests that there was already a market in existence at that time.

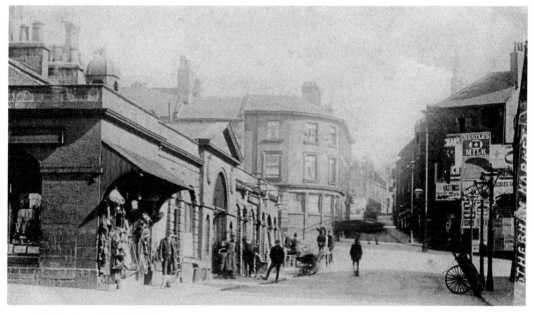

Rotherham Market Hall

The old market hall was erected in 1879 but only lasted nine years, being destroyed by fire on 21 January 1888. It was replaced by a new market hall that served the town until 1971, part of the exterior of which is shown here.

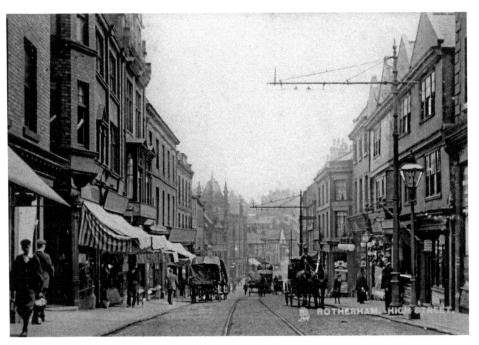

Shops, High Street
This view is looking down High Street, one of the main shopping streets in the centre of the town. The gables of the fifteenth-century Three Cranes Inn can be seen on the right.

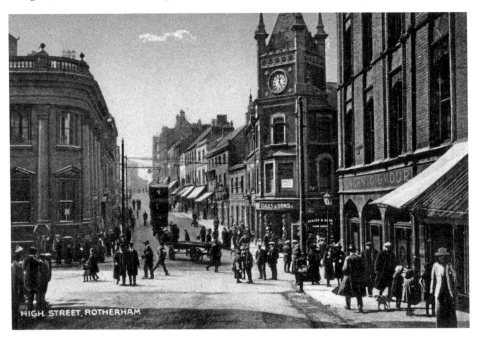

Boot and Shoe Emporium, High Street
Looking up High Street from Doncaster Gate, Scales & Sons' boot and shoe emporium with its clock tower dominates the scene. This was the building that made way for Montague Burton's men's outfitters store.

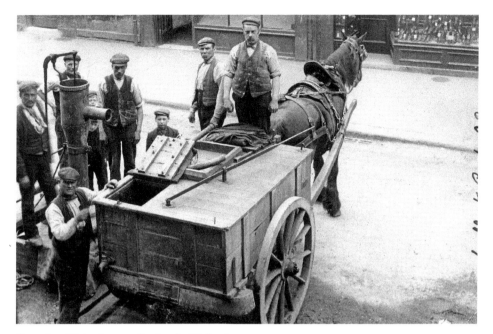

Pumping Water from a Spring in Wellgate

This street takes its name from the springs that surfaced here and provided the early town's water supply. The spring water flowed down Wellgate and College Street and eventually flowed into the River Don. The water was pumped into reservoirs in Quarry Hill and The Crofts. The water supply later became polluted and was abandoned.

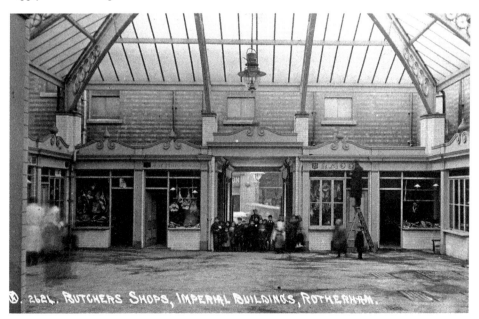

Interior Courtyard, Imperial Buildings

This shows the interior courtyard and glazed roof of the Imperial Buildings. As can be clearly seen, this was where butchers' shops were located. A butcher's name is just being painted above a shop window.

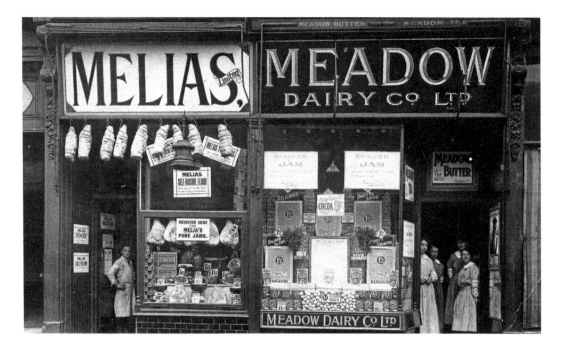

Melias Store, College Street, Rotherham

In the early twentieth century Melias had a presence on high streets across the country. They sold general groceries and packaged their own butter and sugar. They became a casualty of the spread of superstores.

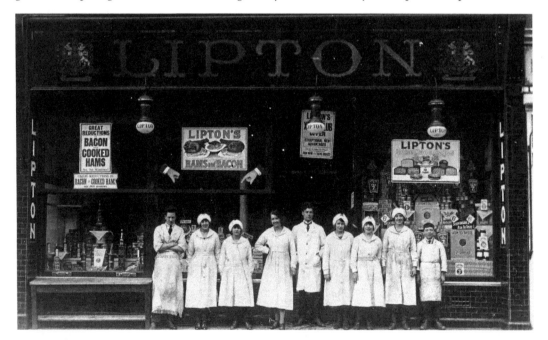

Lipton's Store

Lipton's, like Melias, was once a familiar name on every high street. Lipton's tea was a national favourite. Founded in Glasgow by Thomas Lipton in 1871, by 1881 there were 200 grocery stores and the number had grown to 3,000 stores by 1929.

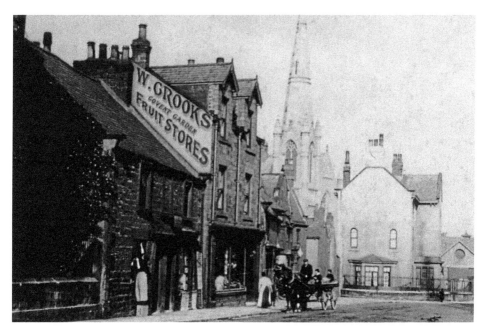

The Covent Garden Fruit Stores

Crooks' Covent Garden Fruit Stores on Moorgate Street is shown here in around 1913. Note the lady standing on a box cleaning the shop windows.

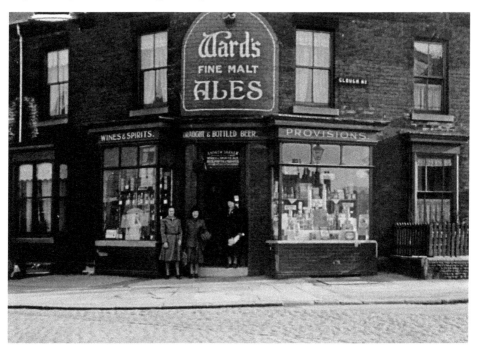

Clough Road Off-Licence

A grocery shop-cum-off-licence is shown on the corner of Clough Road, Masbrough. The sign says the shop sells draught as well as bottled beer, so at busy times there might have been a queue of people carrying their own jugs and other containers for the draught beer.

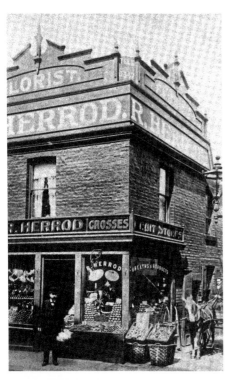

Herrod's Greengrocer's Shop
Bowler-hatted Mr Reed Herrod stands beside the meticulously balanced displays of fruit and vegetables outside his greengrocer's shop in College Street.

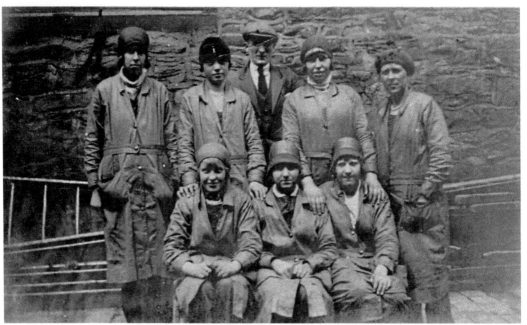

Joe Bentley's All-Girl Window Cleaning Team
The team are posing in front of their ladders. This firm began business in 1920 and in 2020 celebrates its centenary. Not all local window-cleaning firms seemed to use ladders. In the *Rotherham Advertiser* on 17 March 1928 an advert in the situations vacant column appeared stating 'WANTED 2 tall Girls for Window Cleaning'!

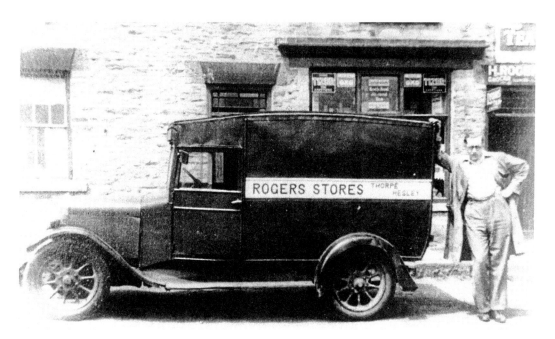

John Rogers' Delivery Van
John Rogers stands with his delivery van outside the family store in Thorpe Hesley. His father ran the shop from the 1930s to the 1980s.

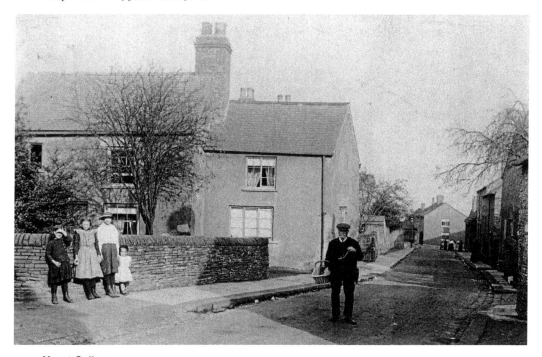

Yeast Seller
A yeast seller or 'barm man' conducting his deliveries in Thorpe Street at Thorpe Hesley around 100 years ago. Itinerant tradespeople were common at that time. It is said that he would ask, 'Do you want a bit missus or can ya manage?'

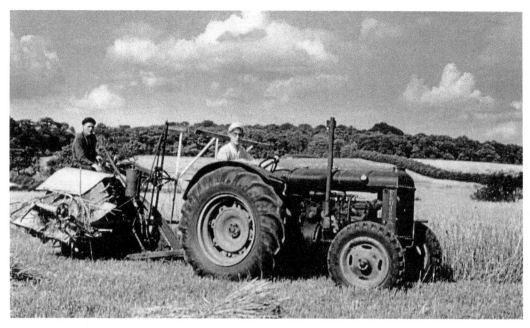

Farmworkers Binding Oats

Farmworkers bind oats near the Sheepwash, between Thorpe Hesley and Wentworth, around 1950. Graham Waller is driving a Fordson Standard tractor and Don Watson is working the binder.

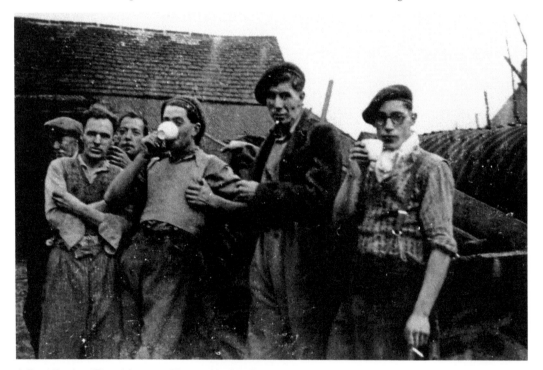

A Rest During Threshing at a Thorpe Hesley Farm

A tea break from threshing on Bownan's Farm, Thorpe Hesley, is being taken here in the 1950s. Even when the process was partly mechanised it was still hard work.

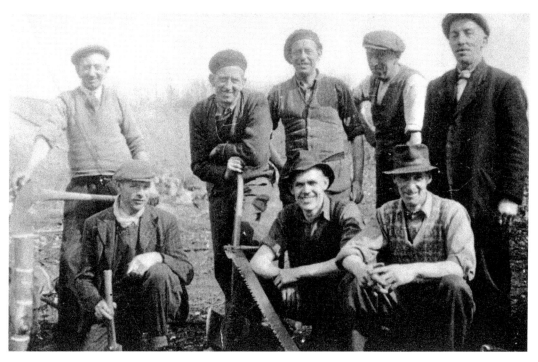

Estate Workers on the Wentworth Estate
Their saw and axes reveal that they are woodmen. Management of the estate woodlands for timber, wood and bark production or for the breeding of game birds has gone on for hundreds of years.

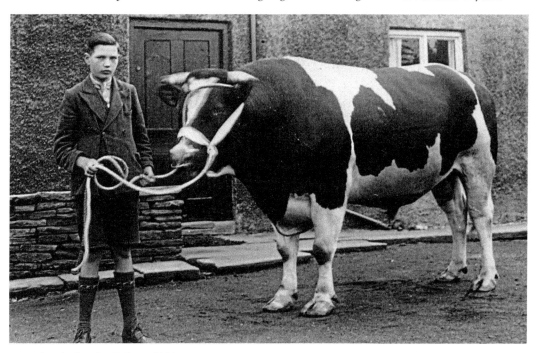

Ready for the Bakewell Show
Leslie Parramore is holding a bull at Bowman's Farm, Thorpe Hesley, ready for the Bakewell Show.

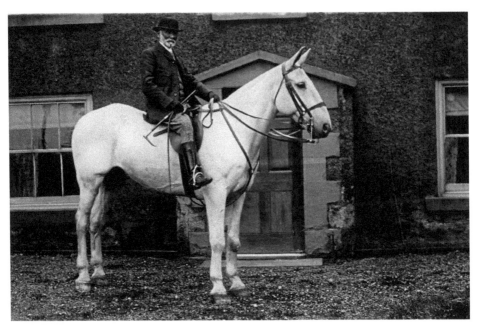

William Shaw and Grey Gander
William Shaw, tenant farmer, sits on his horse, Grey Gander, outside Rockingham House Farm, Upper Haugh.

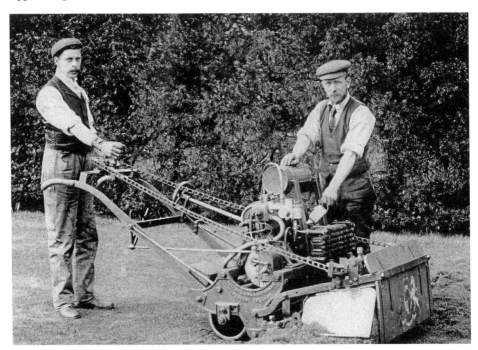

Walter Chapman, Gardener at Wentworth Woodhouse
Walter Chapman (left) and a colleague are at work in the gardens at Wentworth Woodhouse with their petrol-driven lawnmower. Mr Chapman lost his right arm in an accident when he was a boy but became a valuable member of the estate's gardening team.

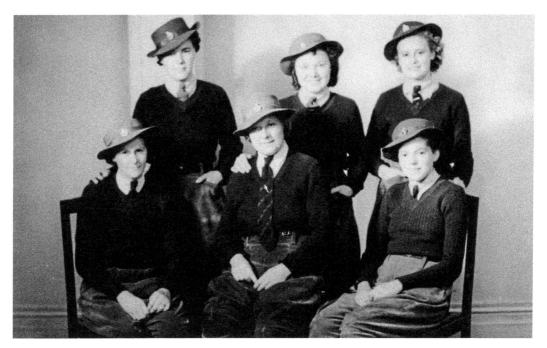

Land Army Girls

A group of Land Army girls who worked on Rotherham Council's Herringthorpe Fields during the Second World War pose for the camera. By the end of the war the Women's Land Army had 80,000 members nationally.

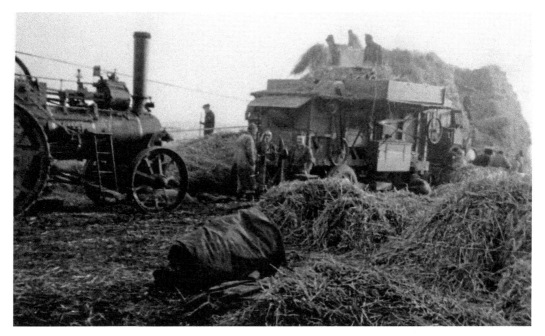

Threshing Grain on Herringthorpe Fields

The photograph was taken during the Second World War. Close inspection reveals that many of the workers are female, presumably members of the Land Army.

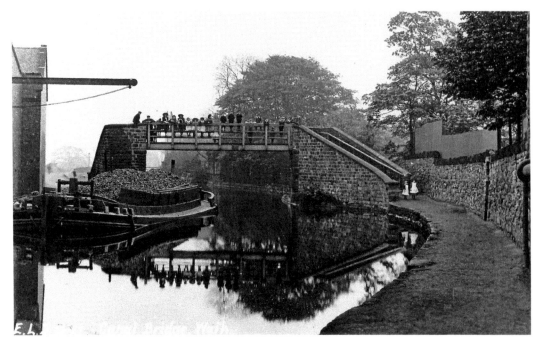

The Dearne and Dove Canal, Wath
This 10-mile-long canal between Swinton and Barnsley was completed in 1804. There were two branches to Elsecar and Worsbrough. It triggered increased coal production and the expansion of settlement.

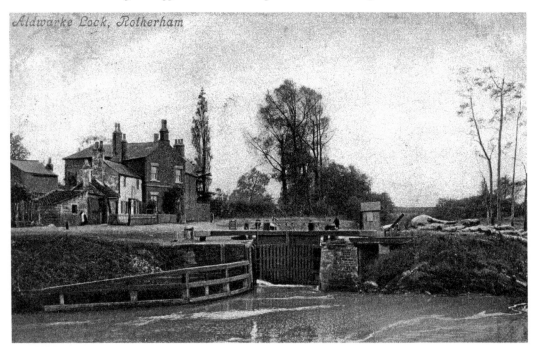

Aldwarke Lock
The lock was built to allow canal barges to bypass Aldwarke Weir on the River Don. In the past coal, iron and steel would have been important cargoes. The lock is still in use today.

5

People and Events

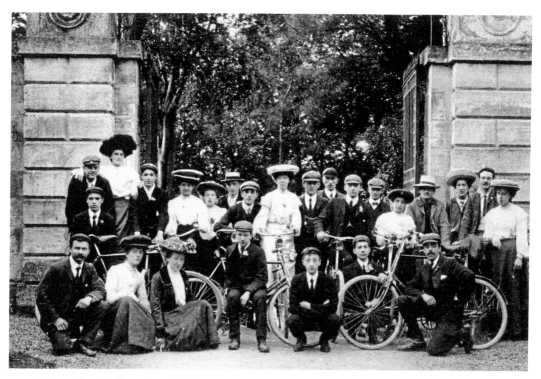

Edwardian Cyclists Outside Wentworth Park

So many events have been captured on postcards and family photographs: outings, sports activities, operatic performances, Whitsuntide celebrations, christenings, marriages – the list is almost endless. Pictured here is a group of Edwardian cyclists at the gate of the North Lodge at the entrance to the park at Wentworth Woodhouse. There are no high-vis jackets or safety helmets in sight. The ladies wear smart hats and the men and boys have collars and ties.

Outing to Sherwood Forest

Thorpe Hesley farmers and innkeepers pose for a group photograph on an outing to Sherwood Forest. This was a popular destination for day trips by waggonette and charabanc. Note there is not a bare head in sight!

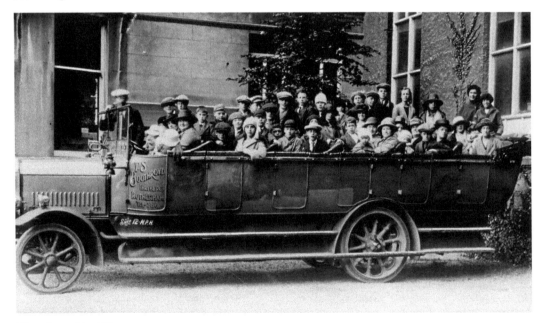

Charabanc Day Trip

This crowded charabanc is full of members of Canklow Wesleyan Band of Hope on a day trip to Matlock in 1924. The charabanc belonged to T. S. Boothroyd of Thrybergh and had a maximum speed of 12 miles per hour.

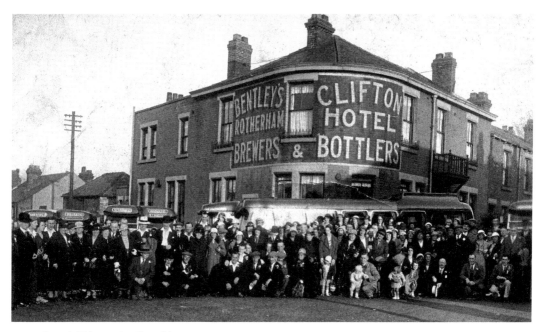

Coach Trip to the Seaside

Members of a coach trip pose outside Clifton Hotel at the corner of Clifton Lane with Badsley Moor Lane. One of the coaches says Scarborough on the front and that it was a seaside trip is confirmed by a little girl in the front row with a bucket and spade.

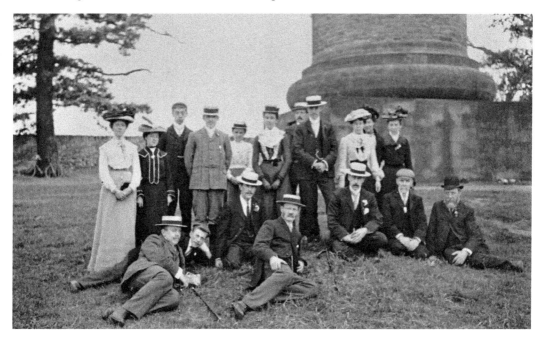

Visit to Keppel's Column

This is an Edwardian outing to Keppel's Column with straw boaters well in evidence. The monument, which was begun in 1773, went through two design changes before it was completed in 1780. It is a monument that continues to dominate the skyline.

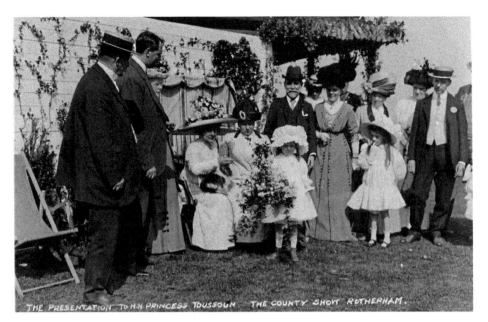

THE PRESENTATION TO H.M PRINCESS TOUSSOUN THE COUNTY SHOW ROTHERHAM.

The Yorkshire Show, 1911

A royal occasion at the Yorkshire Show in Rotherham in 1911 is captured on camera. The show was held over three days between 27 and 29 July and attracted more than 37,000 visitors. The caption states that a presentation is being made to Princess Toussoun of Egypt. According to the *Rotherham Advertiser* the princess judged the children's class of the dog show. It is unclear which lady in the photograph is the princess.

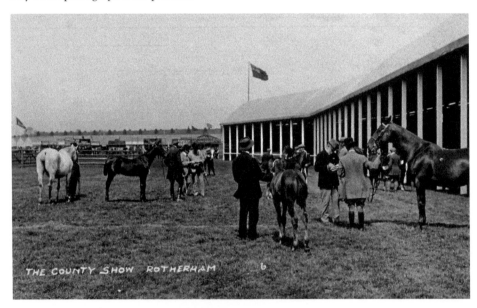

THE COUNTY SHOW ROTHERHAM

The Yorkshire Show, Herringthorpe Fields

This is another view of the Yorkshire Show when it was held in Rotherham on Herringthorpe Fields at an unknown date. Until 1951, when the permanent Harrogate showground was purchased, the Great Yorkshire Show was peripatetic, moving from one town to another across the county. More than thirty towns held the show between 1838 and 1950.

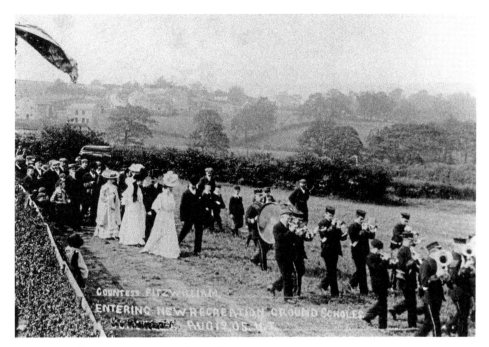

Opening of Scholes Recreation Ground

The opening took place in 1905, the ceremony being headed by Countess Fitzwilliam of Wentworth Woodhouse. Contemporary reports said the countess was dressed in 'heliotrope trimmed with satin' and wore a hat decorated with 'large ostrich feathers and chiffon'.

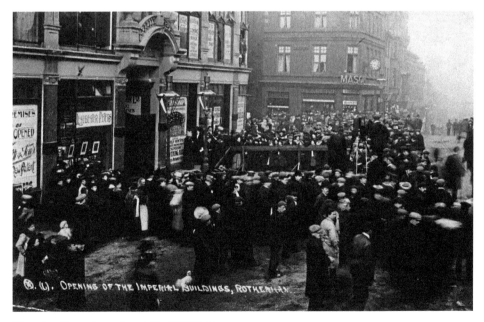

Opening Ceremony, Imperial Buildings

A large crowd is gathered outside the Imperial Buildings during the opening ceremony in 1908. The ceremony was conducted by Sir Charles Stoddart, managing director of Park Gate Iron & Steel Works and four times mayor of Rotherham.

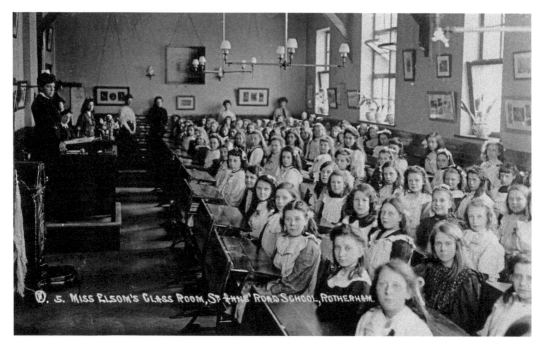

St Ann's Road School, Rotherham

This postcard shows Miss Elsom's classroom at St Ann's Road School. It was posted in 1908. Class sizes were very large in those days!

Boys at Barrow School, Wentworth

The photograph shows Standards I and II in 1905, with some fancy collars on each row!

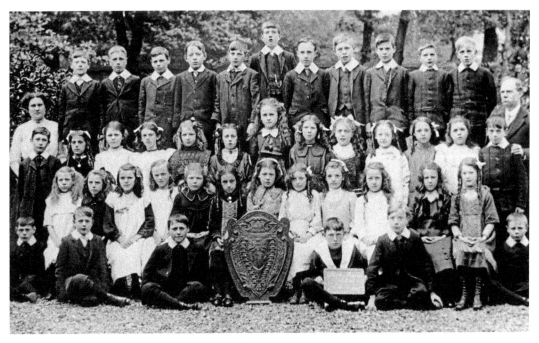

Standard V at Thorpe Hesley School, 1912
Eton collars for boys and ribbons in the hair for girls were both popular at that time. The shield was for good attendance.

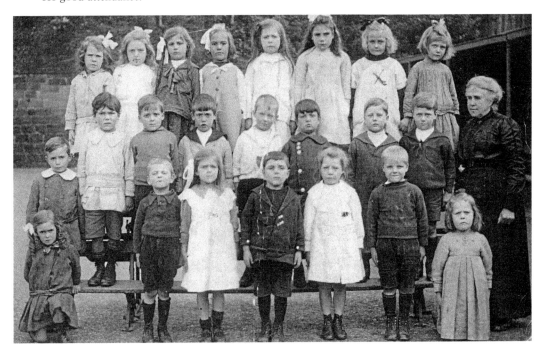

Wentworth Infant and Girls' School
Standing strictly to attention, a class at Wentworth Infant and Girls' School in the early 1920s is shown with their teacher, Miss Hannah Hoyland.

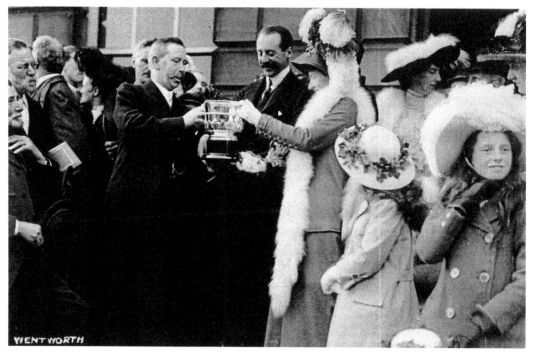

Christening of Viscount Milton, 1911

A miners' representative presents a silver christening bowl inlaid with gold at the christening of Peter, Viscount Milton, on 11 February 1911. There were 7,000 official invitations issued and it was estimated by the *Rotherham Advertiser* that between 50,000 and 100,000 members of the public would also turn up.

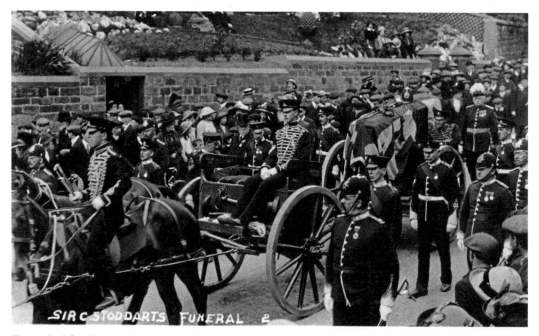

Funeral of Sir Charles Stoddart, 1913

Sir Charles was not only a leading industrialist but also a great benefactor to the town.

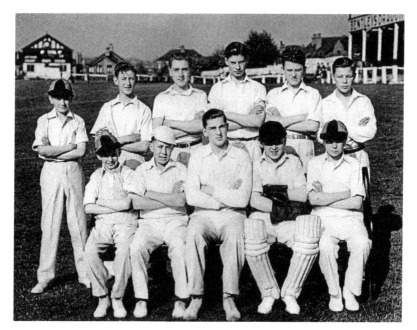

Rotherham Boys' Cricket Team

The team line up at the Clifton Lane ground in around 1946–47. Keith Kettleborough (1935–2009), who went on to play professional football for Rotherham United, Sheffield United, Newcastle United, Doncaster Rovers and Chesterfield, is on the extreme left of the front row.

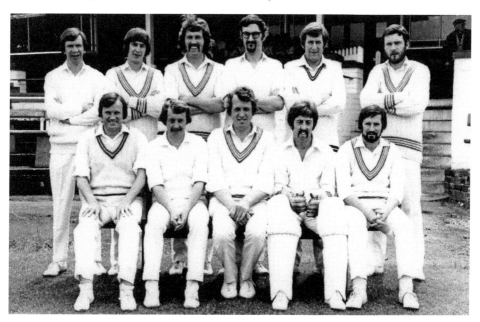

Rotherham Town Cricket Team

Rotherham Town Yorkshire League first eleven cricket team pose for a photograph in 1974. Back row, from left to right: John White, Barrie Eastwood, Ken Leavers, Alan Harding, Trevor Cottam and Brian Roper. Front row: Alan Simmonite, -?-, Mike Bentley (captain), Darrel Guy and Harold Price.

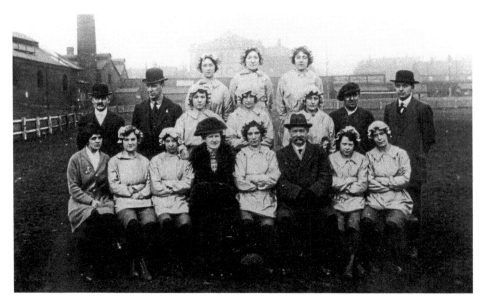

Early Rotherham Women's Football Team
In this early Rotherham women's football team photograph all the players are wearing mop caps. They are all in their playing positions, with the goalkeeper (centre) and two fullbacks in the back row, the three halfbacks in the middle row and the five forwards in the front row. The centre-forward has the ball between her feet.

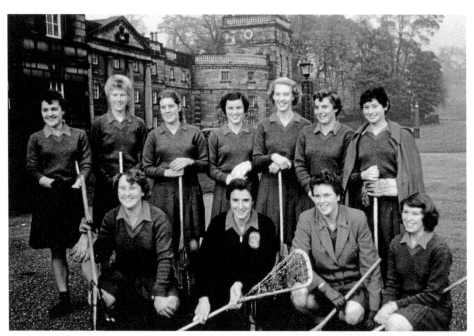

Lady Mabel College Lacrosse Team
The team pose outside the mansion at Wentworth Woodhouse. This was a women's physical education teacher training college from 1949 until 1976. The college was named after Lady Mabel, sister of the 7th Earl Fitzwilliam, who devoted a great deal of her adult life to promoting the education of girls and young women.

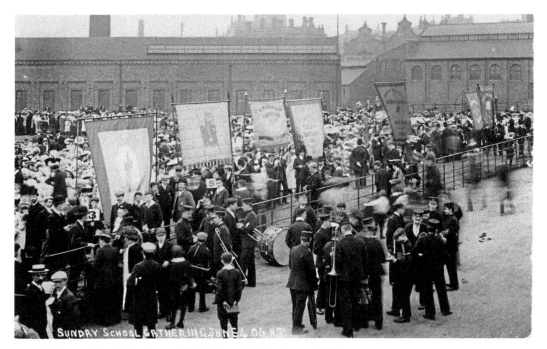

Whitsuntide Gathering on Main Street, Rotherham, 1906

A Whitsuntide gathering in Rotherham is assembling on the 'Stattis' Ground on Main Street. Notice the band's big drum. 'Stattis' is a corruption of 'statute'. At these fairs, held at the end of the farming year in November, farmers and farmworkers came together to clinch new contracts. Bargains were sealed with a small sum of money called 'a fastening penny'.

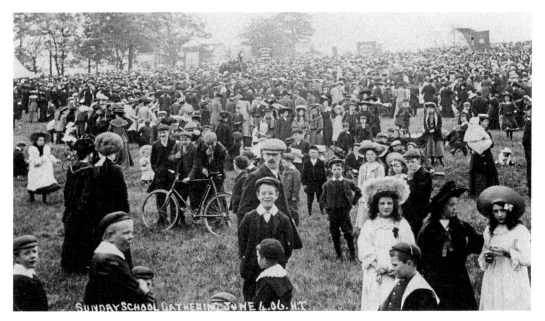

Whitsuntide Gathering at Clifton Park, 1906

This is another Whitsuntide gathering, probably in Clifton Park, again in 1906. It is a very large gathering of several thousand, with everyone dressed in their Sunday best.

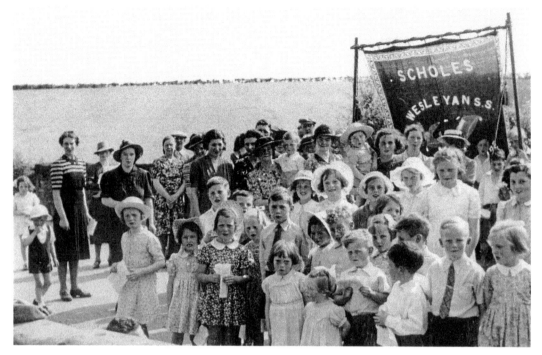

Whitsuntide Gathering at Scholes, 1942

A further Whitsuntide gathering is ready for its parade, this time at Scholes in 1942. The parade was led by the Silverwood Prize Band.

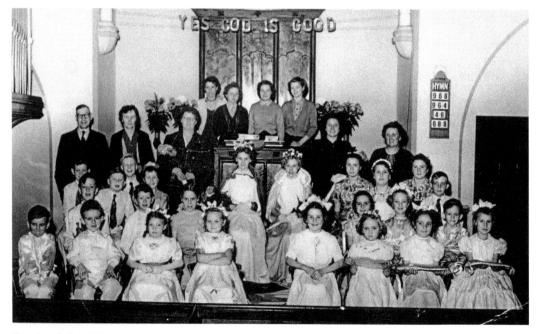

Sunday School Queens

Sunday School Queens are shown at Thorpe Street Methodist Chapel, Thorpe Hesley, in 1953. The queens are Margaret Brooks and Edna Earnshaw.

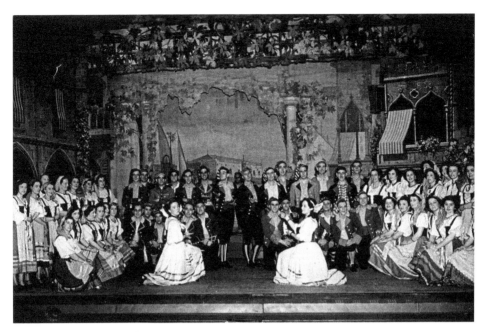

Greasbrough Operatic Society
The cast of Greasbrough Operatic Society's production of Gilbert and Sullivan's *The Gondoliers* in 1950 display their magnificent costumes. The show was performed at the Regent Theatre in Rotherham.

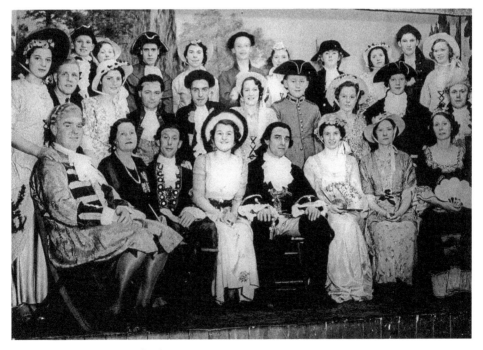

Thorpe Hesley Operatic Society
The cast in a production by Thorpe Hesley Operatic Society pose for the camera, *c.* 1938. No effort has been spared in the costume department.

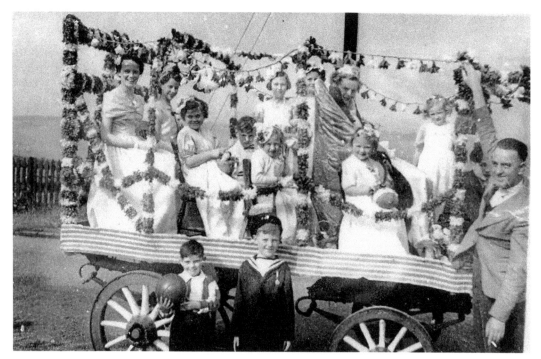

Coronation Float

This is a beautifully decorated float to celebrate the coronation of Elizabeth II in 1953. This float was the work of the residents of the cottages on Barnsley Road and at Barley Hall in Thorpe Hesley. The queen was Christine Batty.

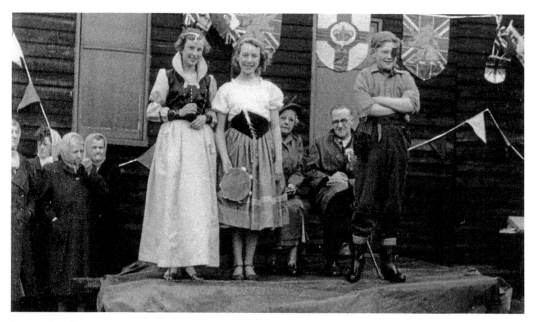

Coronation Fancy Dress Competition

Three competitors from Hesley Bar and Hesley Lane in Thorpe Hesley take part in a coronation fancy dress competition in 1953. They are, from left to right, Pat Watson, Shirley Cooper and Eric Belfitt.

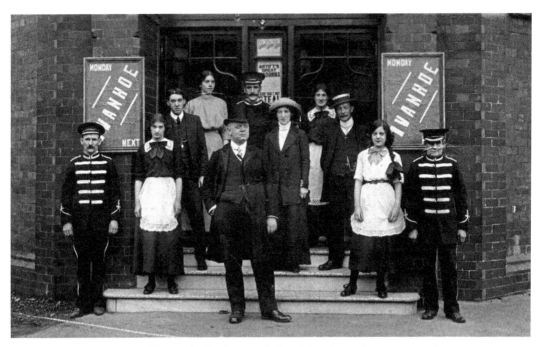

Staff of the Premier Cinema in Kimberworth Road, Masbrough
The manager looks very smart in his top hat but he is outdone by the smartly uniformed commissionaires. Next Monday, as shown on the signs, you could see the historical drama *Ivanhoe*, which was released in 1952.

Thorpe Hesley Pit First Aid Team
This photograph was taken on the steps of Hope Chapel. Only three of the men shown are not wearing ties.

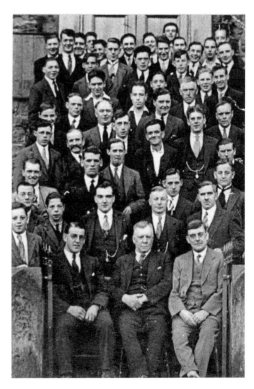

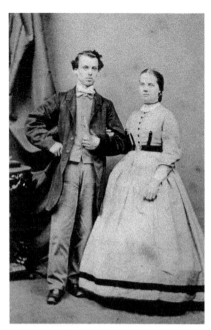

Abraham and Elizabeth Jenkinson
This very early studio photograph, possibly dating from the 1870s, shows Abraham Jenkinson of Thorpe Hesley and his wife Elizabeth (née Hoyland). Abraham died in 1935 aged ninety-one. In later life, when he was interviewed, he said his main food as a boy was 'oatcake, treacle and milk'.

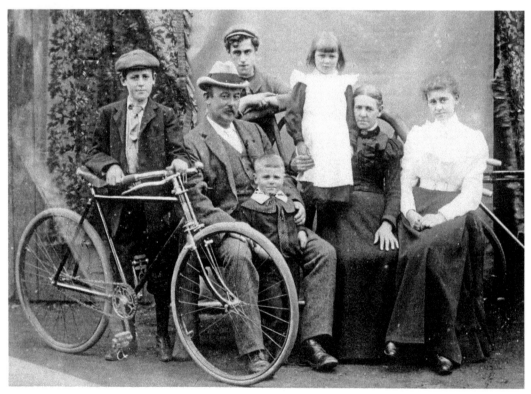

John Mallinson and Family
John Mallinson and family of Brook Hill, Thorpe Hesley, pose for this studio photograph in the late 1890s. John Mallinson owned the undertakers/joiners shop in the village. A bicycle was a status symbol in those days.

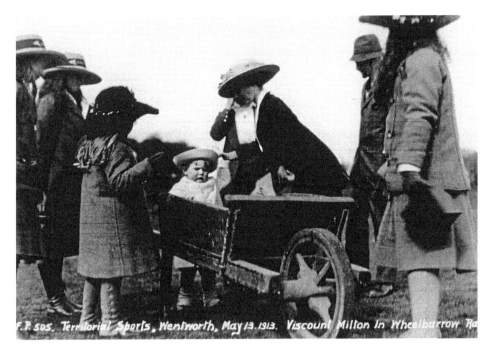

F.P. 505. Territorial Sports, Wentworth, May 13, 1913. Viscount Milton In Wheelbarrow Ra

Wheelbarrow Race at Wentworth Woodhouse

Peter, Viscount Milton, heir to the Fitzwilliam estate, is being prepared for the wheelbarrow race at the Territorial Sports Day at Wentworth Woodhouse in May 1913. Guess who won?

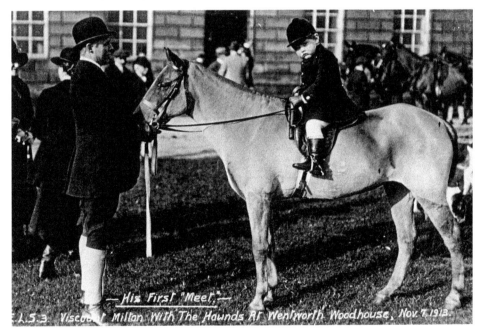

— His First "Meet." —

L.S.3. Viscount Milton With The Hounds At Wentworth Woodhouse, Nov. 7. 1913.

Viscount Milton's First Meet

Another photograph of Peter, Viscount Milton, aged three, who is 'making his first appearance in scarlet' as the *Rotherham Advertiser* put it, when the Fitzwilliam (Wentworth) Pack met at Wentworth Woodhouse on 7 November 1913.

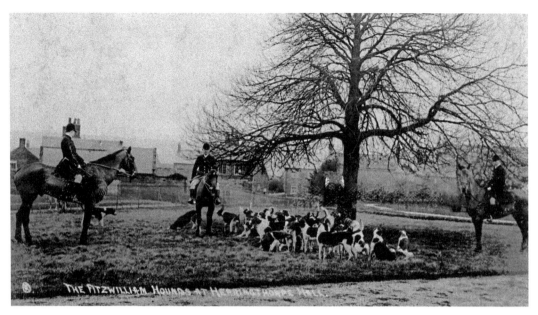

Earl Fitzwilliam's Foxhounds, Herringthorpe Hall
It is reputed that the 6th Earl Fitzwilliam, who died in 1902, spent six days a week during the season either travelling to or taking part in fox hunts, including one day on his Wicklow estate in Ireland, which involved a train journey to Liverpool and an overnight steamer to Dublin.

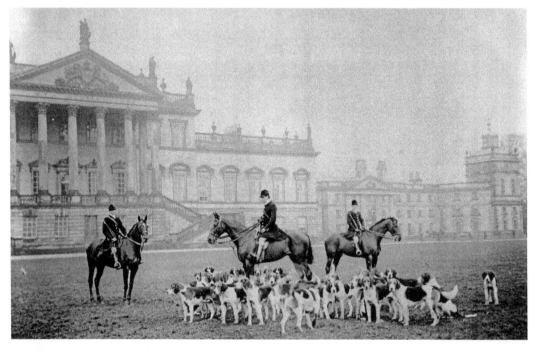

Earl Fitzwilliam's Foxhounds Outside Wentworth Woodhouse
An eagerly awaited fox hunt every year was held on Boxing Day. One writer said it was a 'foot-people's festival' because the hunt was accompanied on foot by hundreds of local people from surrounding villages who came to follow the hounds and track foxes.

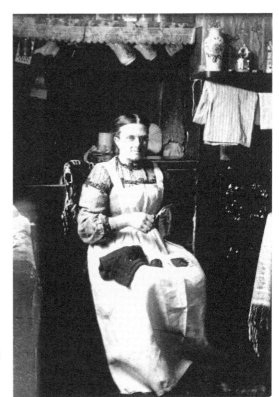

Martha Chesman of Thorpe Hesley

This intimate photograph shows Martha
Chesman of Thorpe Hesley. Martha is sewing
near her cast-iron kitchen range with clothes
drying over the fire. Note the lace-covered
shelf with jugs and mugs hanging below it.

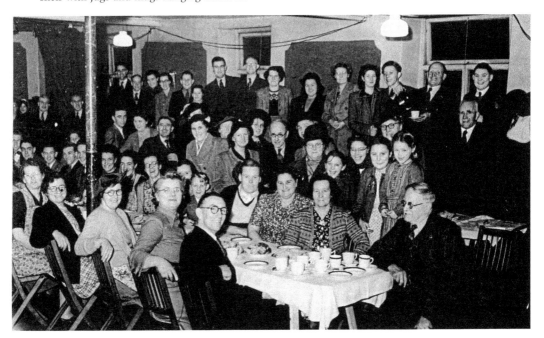

Tea at Hope Chapel, Thorpe Hesley

Chapel-going was an important part of many people's lives until very recently. Hope Chapel has been
converted into a private residence.

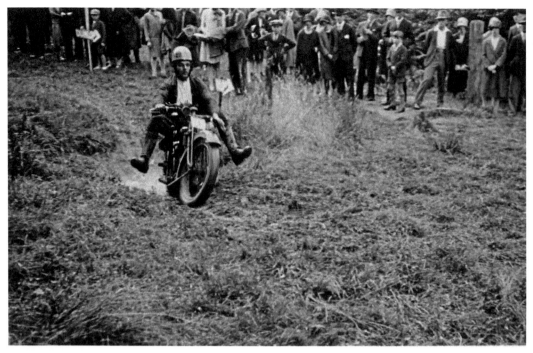

Listerdale Hill Climb Event, 1940s
Outstanding performers at that time included Archie Bingham, Ernest Havenhand and Len Tuplin.

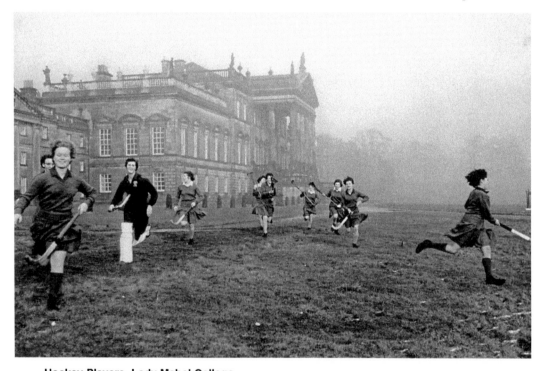

Hockey Players, Lady Mabel College
How many hockey teams can boast a set of dressing rooms and a pavilion as splendid as this?

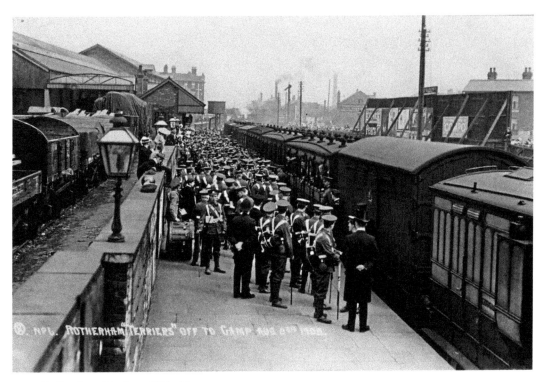

Rotherham Terriers Off to Camp

The caption to this postcard states that it shows the Rotherham Terriers off to camp on 8 August 1908. 'Terriers' was a nickname for the Territorial Army that was formed by the Secretary of State for War, Richard Haldane, in May 1908. The Rotherham Terriers were the 5th Battalion of the York and Lancaster Regiment. They suffered heavy casualties in the First World War.

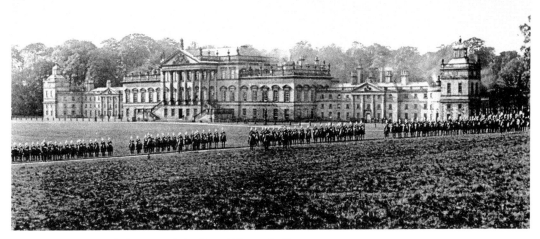

The Wentworth Battery of the Royal Horse Artillery

The unit poses on horseback outside the mansion at Wentworth Woodhouse. This unit fought in the First World War.

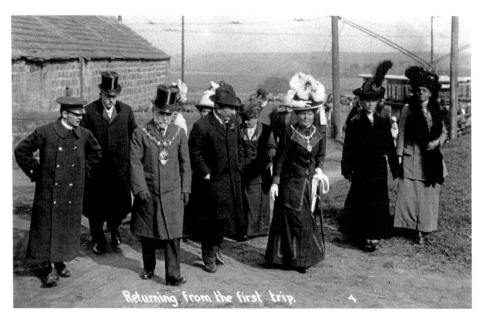

The First Trolleybus Service Beyond the Town Boundaries

In October 1912 Rotherham's first trolleybus to operate beyond the town boundaries came into operation. The new service operated from the Broom tram terminus to Maltby. This photograph shows the mayor of Rotherham and his party returning from the first trolleybus journey on that route.

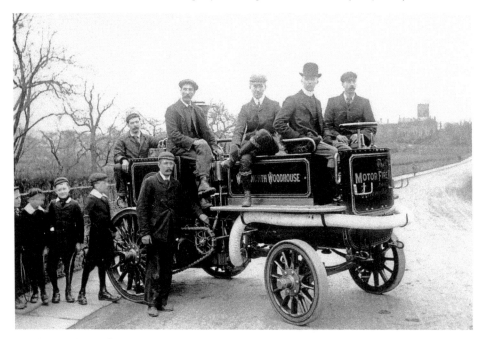

Earl Fitzwilliam's Steam Fire Engine

The fire engine with its crew are shown at Wentworth Woodhouse. They had an enormous house to look after. The fire engine was manufactured by Merryweathers of Clapham, and later Greenwich, in London. This firm manufactured not only large fire engines for borough fire brigades but also small ones suitable for country houses.

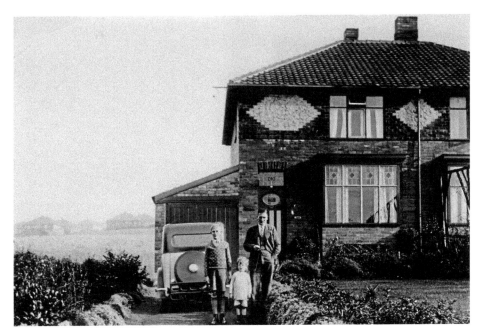

Proud Houseowner Joe Bentley
In the interwar period in the 1920s and '30s suburban residential development was widespread in Rotherham, particularly to the east and south of the existing town. Proud houseowner Joe Bentley, with his two sons Roy and Michael, stand on the drive of their semi-detached house in Brecks Lane, Herringthorpe. Not only do they own a motor car (a Jowett) but also a lean-to garage in which to keep it.

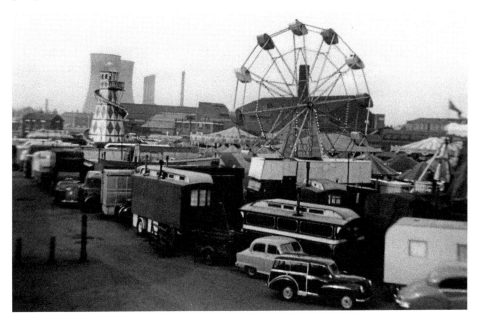

Rotherham Spring Fair, April 1958
The big wheel and helter-skelter dominate the fairground scene. In the background is Rotherham power station.

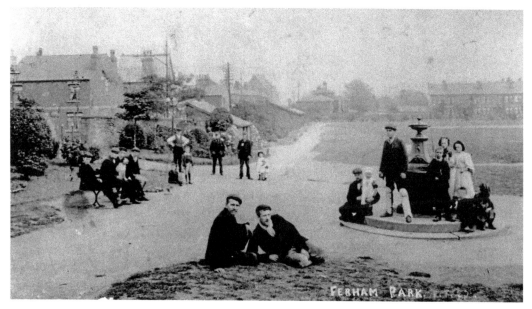

Interesting Group in Ferham Park

Four men are seated on a bench (one man with his dog on his lap), another stands with his hands on his hips, two more pose on the edge of the grass in the foreground, and most interesting (and inexplicably), a man in a suit is wearing white cricket pads.

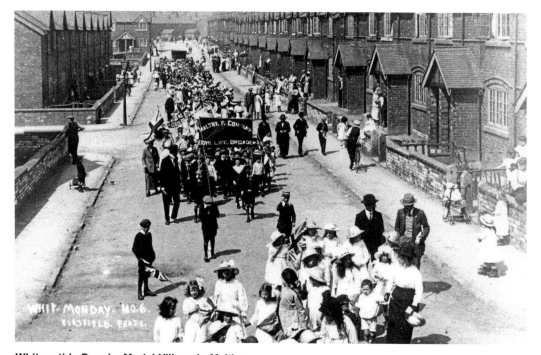

Whitsuntide Parade, Model Village in Maltby

Large parades like this were one of the major events of the year for church- and chapel-goers. Each church had its own banner, there was a marching band, and a Sunday School Queen often headed the procession.

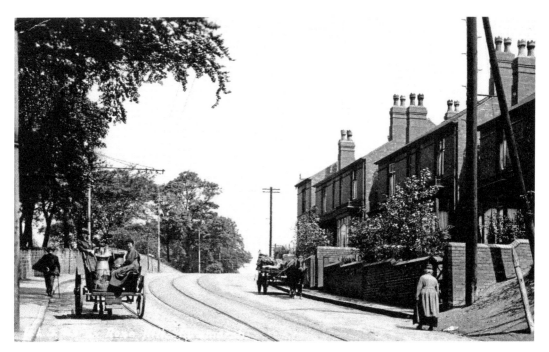

A Milk Cart on Rose Hill, Rawmarsh

Two pedestrians make their way up Rose Hill in Rawmarsh in the morning around 100 years ago. It must be morning because the cart on the left is the milk cart of a local milkman doing his door-to-door deliveries. Two large milk churns can be seen on the cart. No supermarket shelves full of plastic milk bottles in those days.

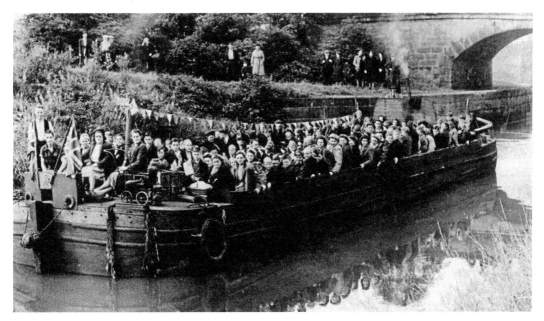

Celebrating VE Day

A large group of children enjoy a boat trip on a decorated barge on the canal at Aldwarke to celebrate Victory in Europe (VE) Day in 1945, marking the end of six years of war.

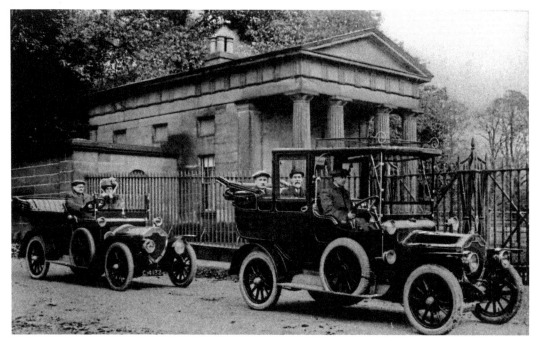

Early Motor Cars Beside the Doric Lodge
The Greek temple shown here is the Doric Lodge on Hague Lane at the entrance to the extensive grounds at Wentworth Woodhouse, the ancestral home from the 1730s until 1979 of the marquises of Rockingham and their successors, the earls Fitzwilliam. Could these cars be early models of the Simplex car that was manufactured by a company owned by Earl Fitzwilliam.

Acknowledgements

First acknowledgement must be made to Michael and Pauline Bentley, for use of a large selection of photographs from their superlative collection of old Rotherham postcards. The two authors would also like to thank Joan Jones most profusely for scanning the photographs, proofreading and operating as 'technical advisor'. They would also like to thank the following for the donation of images and/or accompanying information: Geoff Albiston, Marian Barraclough, Avnil Bramhall, Elma Casson, Chapeltown & High Green Archive, Chris and Pete Chapman, Annie Chesman, Chris Sharp of 'Old Barnsley', Mavis Dungworth, William Dunnigan, June Falding, Alex Fleming, Julie Gregory, Russell Howes, Elvy Ibbotson, Mary Knight, Derrek Leigh, Trevor Lodge, Betty and Sid Myers, John Ogle, Leslie Parramore, Joan and John Portman, Harold Price, Derek Renshaw, Rotherham Archives & Local Studies, Sheffield Industrial Museums Trust, Pat Swift, Margot Tye, Graham Waller, Ann and Howard Willey, and Eve Wood.